# APERTURE

Bernard Faucon, *Les étendoirs* (Clotheslines), 1983

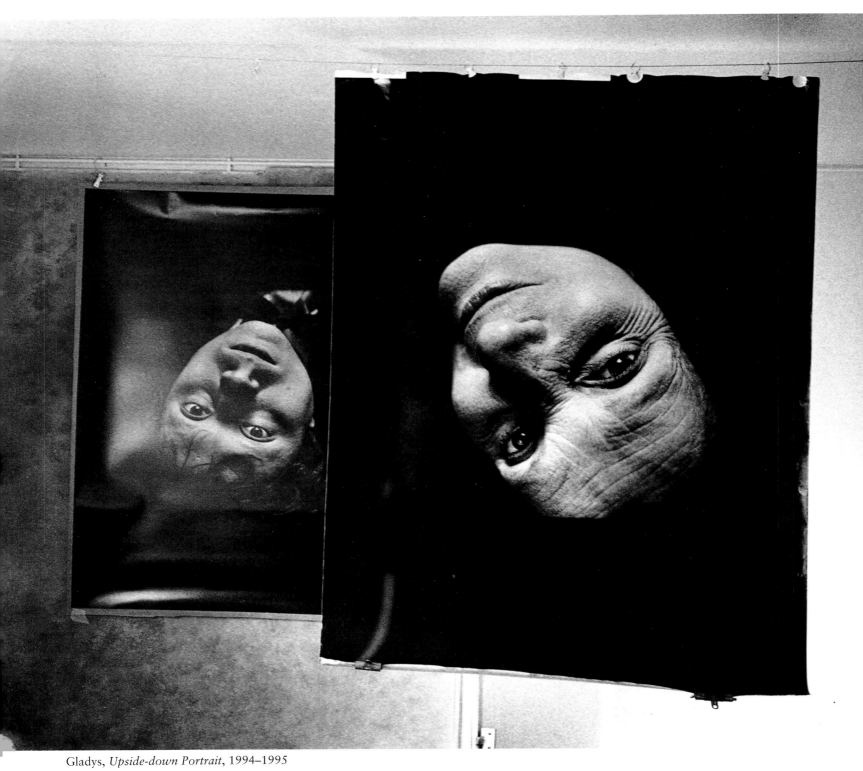

Gladys, *Upside-down Portrait*, 1994–1995

# *1996 Spring Titles From*
# APERTURE

## Nick Waplington
## THE WEDDING
### Essay by Irvine Welsh

*A spirited and freewheeling portrait of marriage—English style.*

Over the course of four years, Waplington became intimately acquainted with two large, working-class families residing in municipally subsidized "council estates" in Nottingham, England. The result was his unforgettable book, *Living Room*, published by Aperture in 1991. Now Waplington revisits his Nottingham friends for *The Wedding*. Through Waplington's vibrant color images pulses a visceral energy that draws us in. Domestic drama at its liveliest, *The Wedding* is a singular artistic experience. British writer Irvine Welsh, author of *Acid House*, contributes an essay of his own insights.

**Photography. 73 color photographs, 9 1/2" x 13", 80 pages, hardcover, ISBN: 0-89381-607-8, $40.00. June.**

## Don McCullin
## SLEEPING WITH GHOSTS

This book presents the life's work of one of the most brilliant photojournalists of our time, Don McCullin, who has raised the status of his craft to that of high art. He has worked as a reporter of wars around the world, but his interests go far beyond the battleground. In this book McCullin has collected some two hundred of what he considers to be his best pictures. They depict unemployed miners collecting coal from the beach at dawn, down-and-outs in London's East End, the homeless in Bradford. His images also reveal a passion for landscape, especially in the mysterious light of India, and a compassionate contact between human beings in a harsh environment.

**Photography/current affairs. 183 black-and-white images, 10 3/4" x 11 3/4", 208 pages, hardcover, ISBN: 0-89381-659-0, $45.00. May. For U.S. distribution only.**

## Michael Nichols
## GORILLA
### *Struggle for Survival in the Virungas*
### Essay by George B. Schaller

*NEW LOWER PRICE!*

In beautiful color photographs, *Gorilla* records the struggle for survival of the gorillas of the Virunga Mountains. Set in a fragile ecosystem threatened with extinction, the book chronicles conservationists' efforts to save this endangered species. Photographer Michael Nichols documents the challenges of the legendary mountain gorillas, the subject of the 1988 motion picture *Gorillas in the Mist*.

**Photography/nature/environment. 74 color and 10 black-and-white photographs, 8 7/8" x 11 3/4", 112 pages, paperback, ISBN: 0-89381-349-4, $19.95. March.**

## Nan Goldin
## THE BALLAD OF SEXUAL DEPENDENCY
### 10th Anniversary Edition
### With a New Afterword by the Author

Nan Goldin calls her book "the diary I let people read." Her photos chart the loss of innocence through barrooms and parties on the social periphery of New York's East Village. She moves into those private spaces, where the body is flaunted and appraised. Her diary unfolds in earnest as she unhesitatingly scrutinizes relationships of all dimensions with her unflinching documentary eye.

**Photography/women's studies. 130 color photographs, 10" x 9", 148 pages, paperback, ISBN: 0-89381-339-7, $27.50. June.**

## FRANCE: New Visions
### *Aperture 142*

Today, photographers in France are more than living up to the French creative legacy; they are breaking ground in the tradition of their artistic forebears. *France: New Visions*, is entirely devoted to recent photographic currents in France. The issue includes a gamut of images from the impressionistic to the purely abstract, from social reportage to fashion and beyond. The images and the texts demonstrate that France is a country of extraordinarily inventive and courageous new visionaries.

**Photography. 30 color and 45 black-and-white photographs, 80 pages, 9 9/16" x 11 3/8", paperback, ISBN: 0-89381-668-X, $14.95. March.**

## EVERYTHING THAT LIVES, EATS

*Everything That Lives, Eats* gathers together photographs by artists as diverse as Cindy Sherman, Sally Mann, and Garry Winogrand in a gastronomic odyssey that is at once humorous, elegant, and highly unusual. Famous chefs such as Marcella Hazan and Nobu Matsuhisa contribute to this publication, and other sometime food philosophers, including John Cage, Gertrude Stein, A. J. Liebling, W. H. Auden, and William Burroughs, are quoted throughout.

**Photography. 80 color and 40 black-and-white photographs, 9 9/16" x 11 3/8", 80 pages, paperback, ISBN: 0-89381-669-8, $18.50. Also available as *Aperture 143*, ISBN: 0-89381-686-8, $14.95. June.**

## Robert Adams

## WHY PEOPLE PHOTOGRAPH
### Selected Essays and Reviews

## FIRST TIME IN PAPERBACK!

*Why People Photograph*—which quickly sold out in its first printing—brings us a new selection of poignant essays by master photographer Robert Adams. In this volume, Adams evinces his firm belief in the importance of art. Photographers "may or may not make a living by photography," he writes, "but they are alive by it."

**Photography. 32 black-and-white photographs, 5 1/2" x 8 1/4", 192 pages, Paperback, ISBN: 089381-603-5, $12.95. April.**

## Robert Adams

## BEAUTY IN PHOTOGRAPHY
### Back in Print With A New Preface!

Written with grace and power, the eight essays in *Beauty in Photography* provide a deep critical appreciation of photography by one of its foremost proponents. The result is a rare book of criticism; one that is alive to the pleasures and mysteries of true exploration. Originally published by Aperture in 1981, *Beauty in Photography* is now a classic of the genre.

**Photography. 23 black-and-white photographs, 5 1/2" x 8 1/4", 112 pages, paperback, ISBN: 0-89381-368-0, $12.95. April.**

## SPECTACULAR VERNACULAR:
### *The Adobe Tradition*

**Photographs by Carollee Pelos**
**Commentary by Jean-Louis Bourgeois**
**Essay By Basil Davidson**

## New Afterword and Images!

*Spectacular Vernacular* celebrates the beauty, variety, and efficiency of traditional adobe architecture in West Africa, Southwest Asia, and the American Southwest. In the severe desert climates of these areas, centuries of working with mud in the construction of homes, mosques, and whole villages have given rise to a remarkable range of styles and forms as visually stunning as any fabled city of myth and imagination—or any postmodern metropolis.

## FIRST TIME IN PAPERBACK!

**Photography/architecture/third-world studies. 150 color photographs, 9" x 12", 196 pages, paperback, ISBN: 0-89381-672-8, $39.95. July.**

## MOTHERS & DAUGHTERS
### *An Exploration in Photographs*

**Essays by Tillie Olsen**
**with Julie Olsen Edwards and**
**Estelle Jussim**

A moving tribute to the emotional, cultural, and intellectual resources of women, *Mothers and Daughters* brings together the works of some seventy-five noted contemporary photographers, among them Bruce Davidson, Eudora Welty, Danny Lyon, Tina Barney, and Nan Goldin. Also included is a poetic essay by renowned author Tillie Olsen, written with her daughter Julie Olsen Edwards. *Mothers & Daughters* offers a rich glimpse into the passions, conflicts, and love of mother-daughter relationships.

**Photography/women's studies/psychology. 26 color and 60 black-and-white photographs, 9 9/16" x 11 3/8", 112 pages, paperback, ISBN: 0-89381-379-6, $24.95. April.**

# ORDER FORM

## FOR INDIVIDUAL ORDERS:

| QTY | TITLE | |
|-----|-------|---|
| _____ | _____ | $_____ |
| _____ | _____ | $_____ |
| _____ | _____ | $_____ |
| _____ | _____ | $_____ |

Subtotal $_____
NY residents add 8.25% sales tax $_____
Canadian residents add 7% GST (Reg. #R125658724) $_____

SHIPPING AND HANDLING CHARGES $_____

| Domestic | first book $6.00 | each add'l $2.00 |
| Foreign | first book $8.00 | each add'l $3.00 |

TOTAL $_____

☐ **Please send me additional information about other Aperture titles.**

Please allow 4–6 weeks for delivery.

Printed in U. S. A

☐ My check or money order in U.S. funds, payable to Aperture, is enclosed.
☐ Please charge my ☐ Visa ☐ Mastercard ☐ American Express

Card # _____ Exp. date _____
Signature _____
Phone _____
Name (please print) _____
Address _____
City _____ State _____ Zip _____
Special shipping instructions _____

### FOR BOOK TRADE AND LIBRARY ORDERS:

Farrar, Straus & Giroux
Sales Department
19 Union Square West
New York, NY 10003
(800) 631-8571
In New Jersey (201) 933-9292

### FOR FOREIGN TRADE ORDERS:

Fax (212) 979-7759 or
call (212) 505-5555, extension 328

SA1234

**APERTURE  20 East 23rd Street  New York, NY 10010  Telephone (800) 929-2323 (24 hours), (212) 598-4205,  fax (212) 598-4015**

# FRANCE: NEW VISIONS

The arena of French photography today accommodates various realities. Several processes play a part in this recent broadening of vision: among them, the progressive creation of a cultural European entity that has encouraged change, an increasingly strong presence of women in photography, and an art market that attracts an ever larger number of photographers—all contributing to a kind of "globalization" of photographic images. France is now unquestionably freed from the strictly humanistic documentary traditions that marked it for so long. The new outpouring is both impressive and inspiring.

"France: New Visions" presents a selection of images by twenty-one contemporary French photographers—some already known, others who will be new to American eyes. These artists are more than living up to the French creative legacy, implementing new aesthetics and technologies, breaking ground in the tradition of such artistic examples as Daguerre, Atget, Brassaï, and Cartier-Bresson. Here are some of the new directions of the medium in France today: these images reveal a French viewpoint that is unexpected by most. A number of us might anticipate something more familiar—the image-clichés of France that have been circulated ad nauseam: fine-boned girls, lush fields of lavender—the romantic or the bourgeois. Instead what we see in "France: New Visions" is an unprecedented reflection of the tumultuous climate of the *fin de siècle*.

Some photographers have chosen to keep their distance from the turmoil, to operate in other ways, outside of day-to-day life—to show enduring situations, and landscapes that change only very slowly. Filmmaker and photographer Raymond Depardon brings us a France that is profoundly rooted in its rural past and traditions; Jeanloup Sieff photographs landscapes that are apparently romantic—until we realize that those valleys and mounds are in fact disfigurations from the first World War. Caroline Feyt's rich visions of nature offer still another, more abstract, take on this subject.

Others use photography not as a way to bear witness, but to invent and relate another kind of perception—which at times may be very far from literal: look at Bernard Faucon's "Love Chambers," Marc Le Mené's poetic and evocative interiors, the narrative quasi-fictions of Sophie Calle. Sometimes the photographer is so close to the subject that we can barely recognize it, as in Marc Pataut's disturbing images of flesh. Dolorès Marat and Mi-Hyun Kim begin with the real—perhaps even the banal—and electrify it with their own distinct energies. Through their images, these photographers express themselves in the first person, speak to us about their concerns, their obsessions—intellectual, metaphysical, artistic, abstract.

Then there are those whose reflex is documentary, or is based on an unshakeable reaction to events taking place in the world. Paris is one of the most important centers for the circulation of news images, and two areas in particular hold the interest of photojournalists at present: Bosnia and Algeria. Recent events in those countries have shocked sensibilities in France, and so are intricately linked to contemporary French history. The powerful documentary images of Jean-Claude Coutausse and Nadia Benchallal take us to the scene of these countries in an extraordinarily intimate way. Others combine a deep social conscience with their own artistic inventiveness: Christine Spengler's collages resound with the clamor of wars she has seen in Iran, El Salvador, and elsewhere; and Christian Boltanski's installations comment poignantly on the tragedies of the Holocaust. A similarly unswerving social principal brings us Jean-François Joly's powerful images of the homeless in Paris, as well as Marie-Paule Nègre's hard-hitting study of the country's "new poverty."

These and the rest of the photographers in "France: New Visions" provide us with a culture we thought we knew—as seen through remarkably innovative and discerning eyes. Trenchant essays by cultural critic Jean Baudrillard and human-rights advocate Dr. Xavier Emmanuelli; poems by Blaise Cendrars, Robert Desnos, Tristan Tzara, and Raymond Queneau; and impressionistic vignettes by fiction writer Annie Ernaux all provide accompaniment to some of the photographs; other images have the comments of the photographers themselves.

"The use a photographer makes of reality forces him to be lucid about what he shows," says Robert Delpire, director of Paris's Centre National de la Photographie, in an interview that appears in this issue. Each of the photographers in "France: New Visions" makes good use of reality: each has a perspective that is unique. "France: New Visions" demonstrates that the rest of the world may still look toward France for creative inspiration, for intellectual invigoration, for profoundly courageous new visions.

*Among the many who worked with us on this publication, Aperture especially thanks Gabriel Bauret, our Guest Editor, without whose insight this book would not be what it is. We are also very grateful for the advice of Robert Pledge, whose guidance was invaluable. Our deep gratitude also goes to: Paul Auster, Pierre Bonhomme, Christian Caujolle, Pierre Devin, Frederick Rossi, and Virginia Zabriskie, for their help in the publication's development. Thanks also to all of the extremely talented photographers whose work we were not able to include in these pages; their images contributed much to the spirit of "new vision" in this issue.*
THE EDITORS

# THE EARTH REMEMBERS

PHOTOGRAPHS BY JEANLOUP SIEFF

TEXTS BY JEANLOUP SIEFF, BLAISE CENDRARS, AND ERNST JÜNGER

*I Only See The Dusty Road*, 1992 (opposite). Upon leaving Bray, I wander in the open countryside, the immense fields, some freshly plowed, others bright yellow with flowering rapeseed. Suddenly, a small English cemetery, set permanently in the landscape, a few chestnut trees in flower, white tombstones, a stone wall, the immaculate lawn . . . and all around the labors of life continue. The sky is pale blue and light gray, at times the sun clouds over, then beats down hard, the wind has lifted, it is two o'clock in the afternoon and the emptiness is absolute.

The horizon shimmers in the hot air that rises and invisible birds tell each other stories. Most of the tombstones are dated May 1916: companions in their regiment, they are now companions in the cemetery. So, it was May, like today, only seventy-five years ago, the same sun, the same fields, the same rubbery smell of rapeseed, but in addition the sound of canons and the day that never ended for these boys who perhaps called for their mothers at this very same spot. I feel I am the guardian of their memory, I who was not yet born when they died, but who could now be their father. —Jeanloup Sieff

*German Trenches at Beaumont-Hamel*, 1992 (page 6). God is absent from the battlefield; the dead left there since the beginning of the war, those poor foot soldiers in their red trousers, forgotten in the grass, were as plentiful but no more significant than patches of cow dung in a field.

It was pitiful to see. —Blaise Cendrars, *The Severed Hand*

One day as I was working my way alone through the thicket, I heard a peculiar hissing and gurgling sound. I went nearer and came upon two corpses in which the heat had awakened a ghastly life. The night was heavy and silent; I stayed there a long time, as if fascinated by this troubling scene. —Ernst Jünger, *The Storm of Steel*

*The Earth Remembers*, 1992 (page 7). A plowed field, typical, reassuring, runs along a local road. Birds dart and glide in the sky, a light wind waves a tuft of grass. "Life is here, simple and peaceful. . . ." And yet I have walked on the surface of this field, and I have collected, almost without seeking it, a piece of shrapnel, or of a bomb, then another, and again another. Everywhere here, the earth remembers and vomits up its memory. In some places, ten shells fell on each plot of land, and turned up the dirt, kneaded it to several meters high. And there are still men, arms, canons there . . . which are brought up from the abysses as the field is plowed. Seventy-five years after the carnage, these "storms of steel" have not finished bringing back the memories of death.

The grass seems innocent as it ripples in the warm wind, but its roots may run alongside a cadaver, or those bits of cold metal that cut short, in midstream, the life of an English youth, or of a German, or of an Australian.

Many men have forgotten, but the earth, the earth remembers. —Jeanloup Sieff

*Translated from the French by Karin Lundell.*

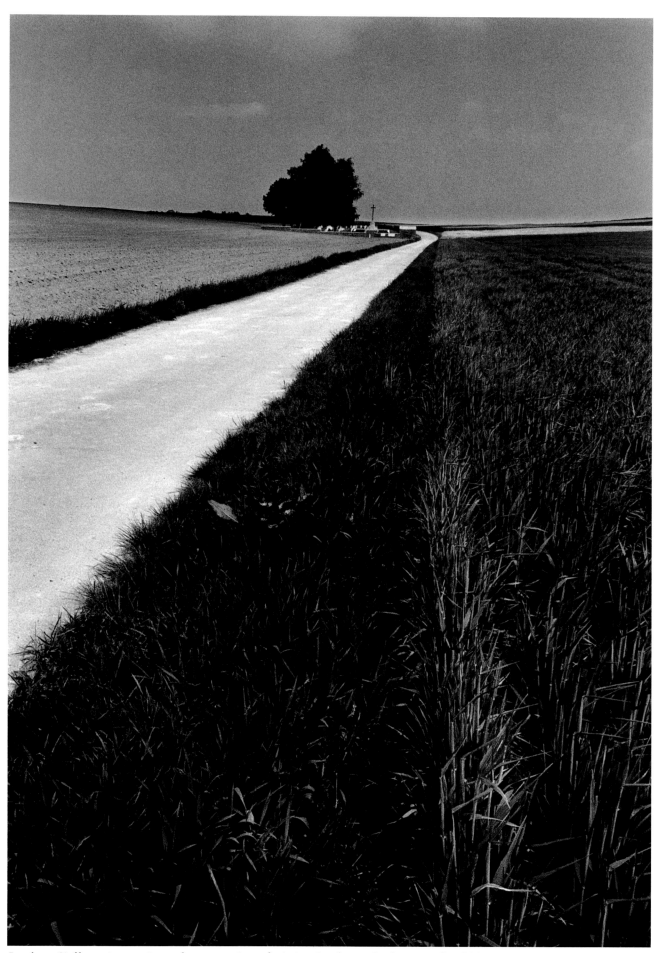

Jeanloup Sieff, . . . *je ne vois que la route qui poudroie* (. . . I only see the dusty road), 1992

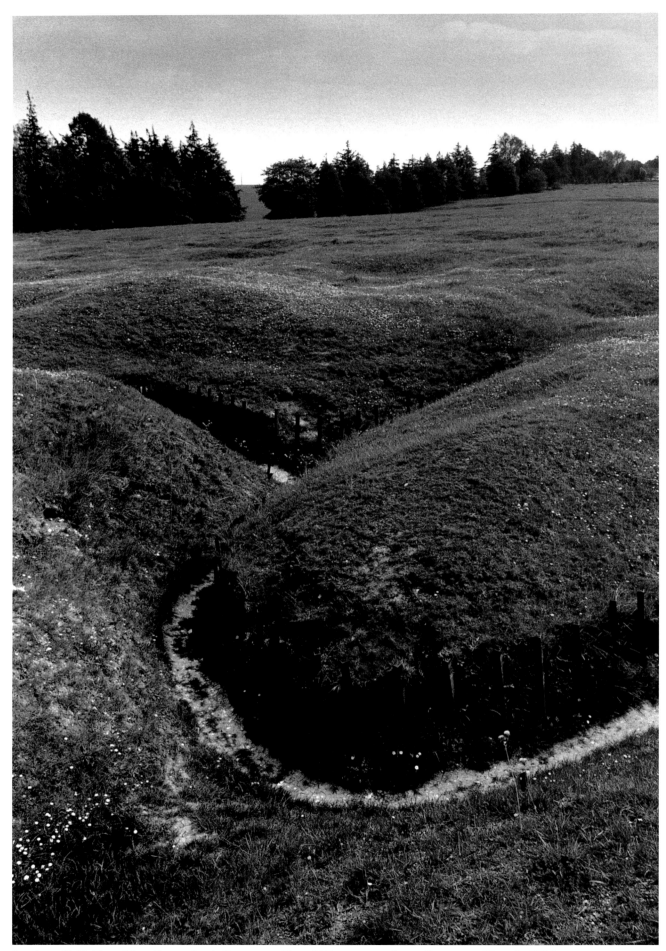

Jeanloup Sieff, *Tranchées allemandes de Beaumont-Hamel* (German trenches at Beaumont-Hamel), 1992

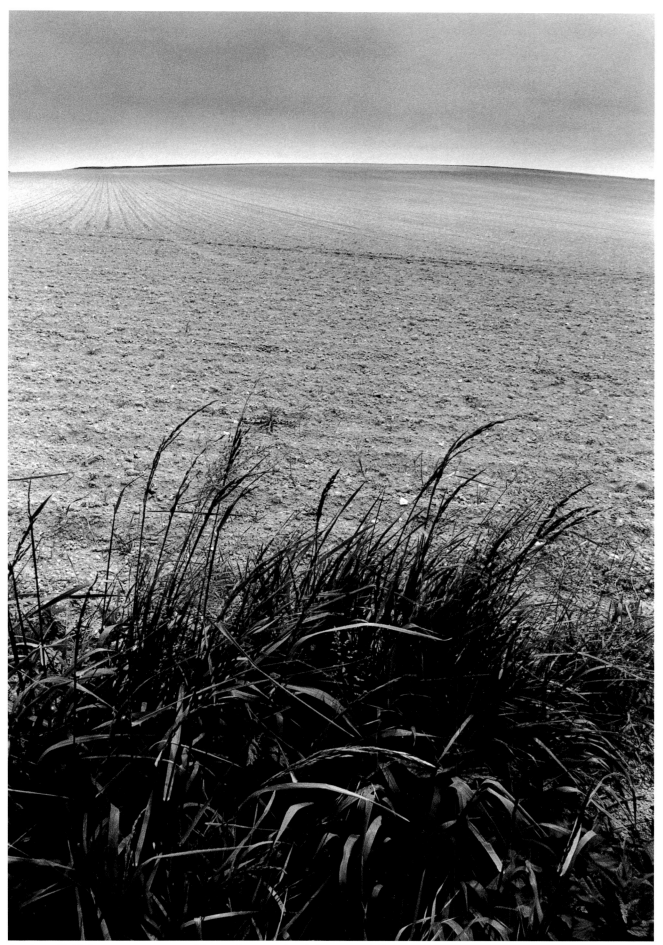

Jeanloup Sieff, *La terre se souvient* (The earth remembers), Somme, 1992

# Midway

## BY ROBERT DESNOS
## PHOTOGRAPHS BY MARC LE MENÉ

*There is a precise instant in time*
*When a man reaches the exact center of his life,*
*A fraction of a second,*
*A fugitive particle of time quicker than a glance,*
*More fleeting than lovers' bliss,*
*Faster than light,*
*And a man is awake to this moment.*

*Long roads strain thru green wreathes*
*to reach the tower where a Lady drowses*
*Whose beauty defies all kisses, seasons,*
*As a star against wind, a stone against knives.*

*A shimmering boat sinks and shrieks.*
*At the top of a tree a flag flaps.*
*A woman—her hair stylish and stockings loose at the ankles—*
*Shows up at the corner*
*Impassioned, shimmering,*
*Her hand shielding an antiquated lamp billowing smoke.*

*And again a drunken dock-worker sings on a bridge,*
*And again a girl bites her lover's lips,*
*And again a rose-petal falls in an empty bed,*
*And again three clocks strike the same hour*
*A few minutes apart,*
*And again a man walking down the street turns back*
*Hearing his name called,*
*But it's not him she's calling,*
*And again a cabinet minister in full dress,*
*Irked by his shirt-tail caught between his trousers and his*
*    shorts,*
*Inaugurates an orphanage,*
*And again a truck barrelling flat-out*
*Thru empty streets at night*
*Drops a marvellous tomato that rolls in the gutter*
*To be swept away later,*
*And again a fire breaks out on the sixth floor of a building*
*Flaming in the heart of a silent, indifferent city,*
*And again a man hears a song—*
*Long forgotten—and soon to be forgotten all over,*
*And again many things,*
*Many other things that a man sees at the precise instant of*
*    the center of his life,*
*Many other things unfold at length in the shortest of*
*    earth's short instants.*
*He squeezes the mystery of this second, this fraction of a*
*    second,*

*But he says, "Get rid of these dark thoughts,"*
*And he gets rid of these dark thoughts.*
*And what could he say,*
*And what could he do*
*That's any better?*

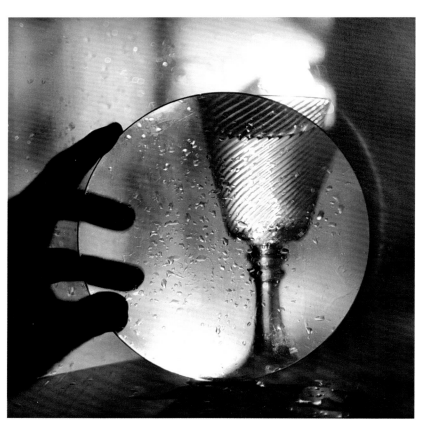

Marc Le Mené, *Untitled*, 1984

Translated from the French by George Quasha.

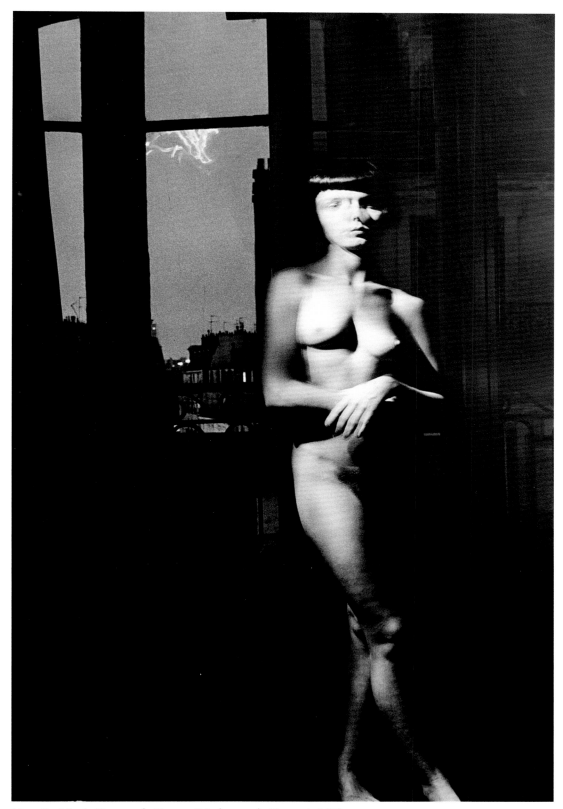

Marc Le Mené, *Nu, rue de Navare* (Nude, rue de Navare), 1988

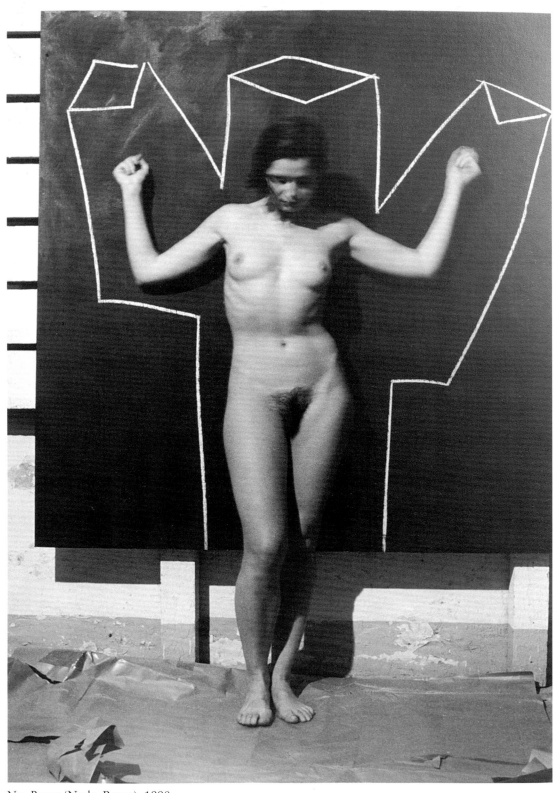

*Nu, Rome* (Nude, Rome), 1990

Marc Le Mené, *Self-portrait*, 1985

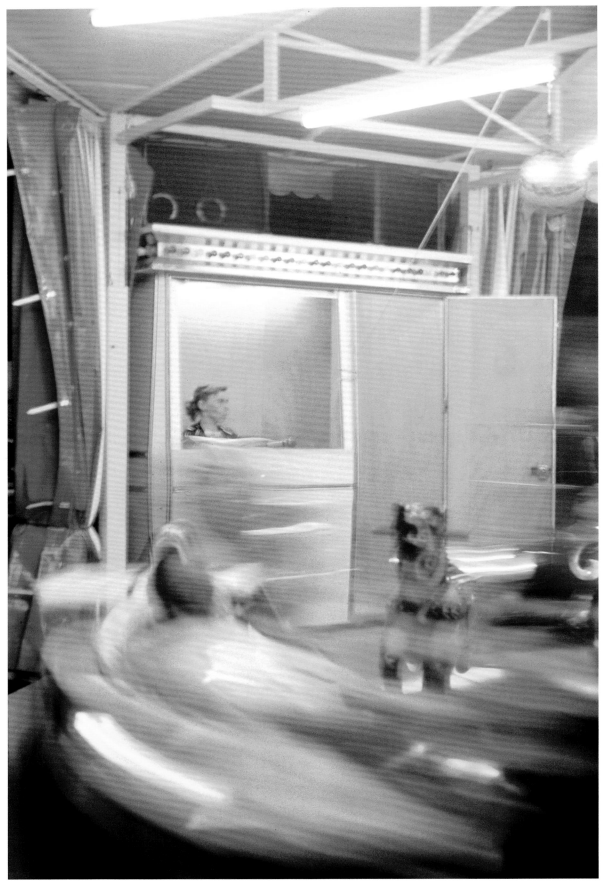

Dolorès Marat, *Fête à Ambialet* (Ambialet fair), 1988

# MOMENTS IN THE CITY

BY ANNIE ERNAUX

PHOTOGRAPHS BY DOLORÈS MARAT

*Over the years, I have acquired the habit of writing down scenes and conversations taken from places I am compelled to visit: the subway and the R.E.R. [Regional Express Trains], hypermarkets. . . . For me it is a way to capture some aspect of the reality of the 1990s.*

In the R.E.R., near the Denfert-Rochereau station, a woman in her forties, wearing no makeup, sits across from her son, a preteen. She is reading a women's magazine. He shifts his legs and hides behind his book bag, showing all the signs that he does not know what to do with his body. I see the title of the article that the mother is reading: "Age Is No Longer an Obstacle to Love." The boy chats to her, asks a question, "So when do we. . . ." She continues reading, does not answer or lift her eyes.

In the new town near the R.E.R. station, a black woman wears a light-brown pleated skirt, a beige blouse, and a black round hat, similar to those worn by Quakers. A girl—I think it is a girl—in jeans and a ski jacket despite the warm weather, leans against the concrete wall overhanging the tracks below and stares emptily into space. Three little girls, one is carrying a bouquet of leaves. A white man, about fifty, walks by athletically, wearing a short-sleeve shirt and a knapsack. A group of young men and women, all dressed in the same outfit: black slacks and white shirts (a religious sect, perhaps, or salespeople from some store?) walk toward the entrance of the station. For a few minutes today, I tried to really *see* people whose path I crossed, all of them obviously strangers. (The custom in large cities is not to *see* people in the streets, whereas in small towns, you have to see people so you can either greet or avoid meeting them.) I felt that for once the very existence of these passersby became real to me, that if I continued this experiment, my view of the world and of myself (how am I seen?) would change.

I hear a voice in the R.E.R.: "I'm jobless, I'm living in a hotel with my wife and child, we have twenty-five francs a day to live on." This is followed by a tale of poverty, repeated probably thirty times an hour, delivered like a monologue from some play. The man is selling *Street-Lamp*, the newspaper of the homeless, for ten francs. His words are humble, "I'm not asking for much, just a small

gesture to help me out," but his tone, out of powerlessness (no one has bought his newspaper), grows increasingly accusatory, even threatening at the end: "Have a good day!" he utters, leaving the train. The social violence that society inflicts on the most needy comes out in the pointed use of a polite phrase that, in this instance, rings reproachful and mocking.

Along with spring, the woman on the billboards with the serious face has returned, her smooth hair pulled up in a chignon. Beautiful, she reveals a breast, lifting it up lightly as if preparing to breast-feed. But the slightly sagging breast is that of an older woman and it is, or is about to be, struck with cancer. The woman's eyes meet those of other women everywhere, in the subway, in the streets. She makes one want to move on and escape that deadly bosom.

For the future: one day, take note of all the advertising billboards in subway stations and their slogans in order to register the imaginary reality, fears and hopes of a moment in time, all the signs of History that memory does not retain, or does not deem worth retaining.

I got off at Châtelet-les-Halles. At the top of the escalator, a man, seated, was begging. His pants, which were cut off at the knees, were slightly raised, revealing the stumps of his amputated legs. They looked like the ends of two enormous penises.

I found that long street in Maisons-Alfort that connects avenue Général-Leclerc with avenue Léon-Blum, I don't know what it's called. I have walked along it five or six times before on my way to Dr. M.'s office. On the right, I recognized the suburban houses, some of which had previously seemed abandoned . . . yet today had opened their shutters. On the left, apartment buildings and an enormous parking lot. Further along, a bulldozer was leveling a public park, probably making way for more apartment buildings. Having passed the income tax office, I could smell the familiar sweetish odor (of some chemical plant?). Near the end of the street, where it narrowed, was the café/betting office, a windshield replacement shop, and a house with the blinds drawn behind an iron gate. There were some teenagers, young Arab girls in groups of two or three (Wednesday—no school in the afternoon—and the weather was fine).

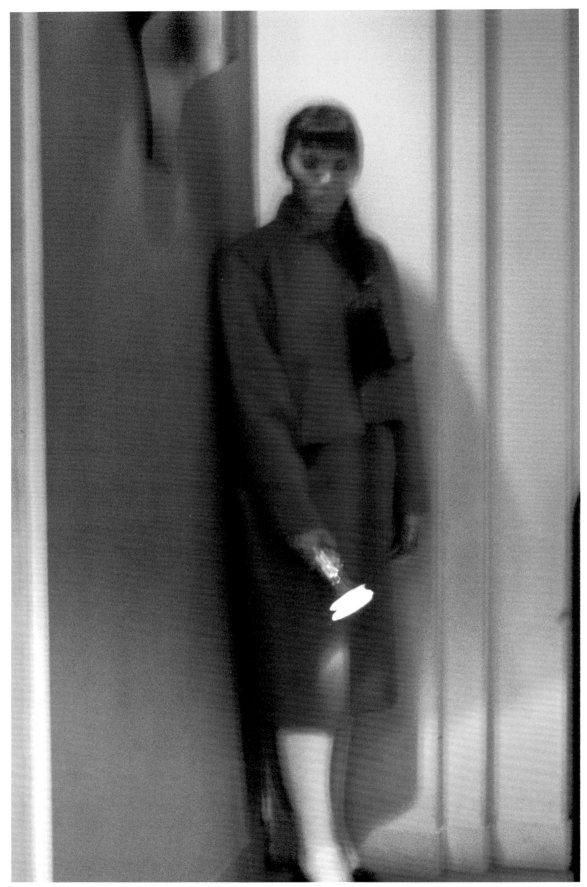

Dolorès Marat, *Femme au musée Grévin* (Woman at the Grévin museum), 1988

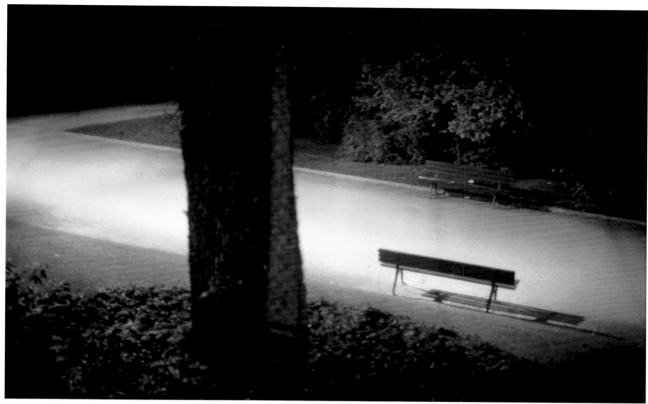
Dolorès Marat, *Square dans la nuit* (Square at night), 1992

I began to like that street in Maisons-Alfort, a suburb that was unknown to me. I felt that it would become a part of my life, be connected to the man I love, like certain streets in Rouen, Bordeaux, London, all places where I have lived.

Returning from Dr. M.'s along this street, I wanted to see the apartment buildings closer up and stroll in the grassy areas that surrounded them before getting back on the subway. Children were everywhere, playing.

At the Yves Saint-Laurent hosiery counter in the Printemps department store, the salesgirl is not around. On the other side of the counter in front of me, a woman shuffles, as I do, through the packets of hosiery. She quickly slips one in a plastic bag and goes off to the perfume counter. I realize that she has just stolen a pair of tights. I register my surprise at having immediately known, even though I was not really watching her, that this woman was stealing something. We are so familiar, I supposed, with the "normal" gestures of consumerism that the act of slipping some merchandise directly into one's bag, rather than carrying it over to the register, was perceived by me as abnormal and I was alerted.

I imagine in particular the woman's feeling of intoxication.

9:00 A.M., the opening of the Auchan Hypermarket, which is almost empty. As far as the eye can see: mountains of tomatoes, peaches, lettuces; parallel aisles, brightly lit, of yogurts, cheeses, and cold meats. I am almost alone in this field of colors and forms. I have a strange feeling of beauty: I am on the edge of Eden, on the first morning of the world. And **everything is edible**. . . . The great childhood dream of endless bounty has come true.

At the other end of the store, far away, are the narrow exits with the cash registers. At the check-out counter, the items thrown in the cart seem small, dull, no different than those bought at the corner grocery store run by the Arab.

In a corridor at the Montparnasse station, a squadron of inspectors in brown uniforms: four or five are lined up against the wall, while four others question a man sharply. The latter is young, dark-skinned, with his hair tied back. It's obvious what is going on; and I feel overwhelmed.

Many of those selling street newspapers seem sad and depressed these days. It's as if the novelty of this way to help the homeless has worn off. The impression is that these charity newspapers,

though we prefer to see them as providing real jobs, are a paltry measure to accommodate poverty, even give it a place, so that it does not become dangerous.

At the Mobil service station, a twenty-year-old boy is at the cash register listening to his transistor. Distracted, he takes my credit-card and inserts it into the machine. A smile crosses his face. The radio announcer is speaking to a woman listener. "Would you object if we said freely over the air words like—I don't know—ejaculation, for example?" "Well, yes, but not too much." "You're right," roars the announcer, "when there's too much, it gets every-where!" I type in my PIN and wait for the mute boy, who seems thrilled, to give me my receipt.

The cashiers in hypermarkets routinely say hello just as they have finished with their previous customer and grab your first item to place it on the moving belt. You may have been in their field of vision for five minutes, but it is only once they start to register your items that they seem to notice you finally and are able to greet you. They are merely following a rule of sales courtesy: "Say hello and good-bye to each customer."

In keeping with the laws of marketing, we exist only for that instant in time when the box of laundry soap and containers of yogurt are exchanged for money.

Sunday night in the R.E.R.: a couple with two children. The small boy falls asleep as soon as he sits down, his mouth shut tight, he looks old. The girl, five or six, blond, is restless. She is wearing, in all innocence, a pair of black tights with a seam—Chantal Thomass style—slightly perverse. Her father tells her repeatedly: "Pull your skirt down, what's the point of wearing one!" The mother, who must have chosen the girl's tights, looks the other way.

On the platform at Châtelet-les-Halles, about midnight. An African with a guitar is singing a long recitative in French. He talks about the world of his childhood, his mother's hut. A white woman also plays guitar, accompanying him. A circle forms around them. All types of people approach, drawn by these words that tell the story of a past that is not theirs. The circle breaks up as the train arrives and re-forms as travelers come down the escalator to the platform.

The hope, always vain, to have nothing more to note down, to no longer be summoned by anything from this world, from the anonymous flow I meet and to which, in their eyes, I belong.

*Translated from the French by Karin Lundell.*

Dolorès Marat, *Gardien de studio TV* (Watchman of TV studio), 1984

Mi-Hyun Kim, *Chez Robert*, rue Saint-Sabin,
Paris, March 1994

Mi-Hyun Kim, *La Pinte*, carrefour de l'Odéon, Paris, January 1994

# In the World's Heart

BY BLAISE CENDRARS

Found fragment

*This Paris sky, cleaner than winter sky lucid with cold—*
*I've never seen nights more starry, more bushy, than this spring*
*With boulevard trees like shadows of heaven,*
*Great fronds in rivers choked with elephant ears,*
*Heavy chestnuts, leaves of plane trees—*

*White water lily on the Seine, moon held by water's thread,*
*Milky Way in the sky flops down on Paris, embraces*
*The city, crazy, naked, upside down, mouth sucking Notre Dame.*
*Great Bear and Little Bear prowl around Saint-Merry, growling.*
*My cut-off hand shines in the skies—in Orion.*

*In this hard cold light, trembling, more than unreal,*
*Paris is like the frozen image of a plant*
*That reappears in its ashes. A sad simulacrum.*
*Linear, ageless, the buildings and streets are only*
*Stone and steel, heaped up, an unlikely desert.*

*Babylon, Thebes, no more dead tonight than the dead city of Paris*
*Blue, green, inky, pitchy, its bones bleached in starlight.*
*Not a sound. Not a footfall. The heavy silence of war.*
*Eye pans from pissoirs to violet eye of streetlights:*
*The only lit space into which I can drag my restlessness.*

*And that's the way I walk Paris each night,*
*From Batignolles to the Quartier Latin, crossing the Andes*
*Under the lights of new stars, greater, more puzzling:*
*Southern Cross more prodigious, each step one takes toward it as it*
*emerges from the old world*
*Above the new continent.*

*I'm the one who has run out of past. Only my stump still hurts me.*
*I've rented a hotel room to be alone with myself.*
*A brand-new wicker basket to fill up with manuscripts.*
*No books, no pictures, no knick-knacks to please me.*

*Desk cluttered with newsprint,*
*I work in this empty room, behind a blind window,*
*Bare feet on red congoleum, play with balloons, a child's trumpet.*
*I work on* THE END OF THE WORLD.

Translated from the French by Anselm Hollo.

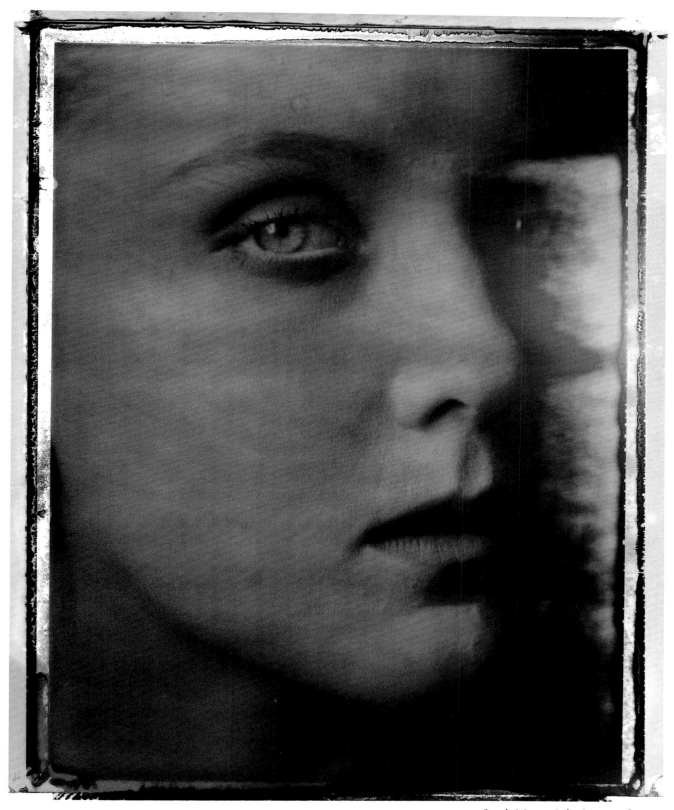

Sarah Moon, *Julie Stouvenel*, 1991

# AUTOBIOGRAPHICAL STORIES

## INSTALLATIONS AND TEXTS BY SOPHIE CALLE

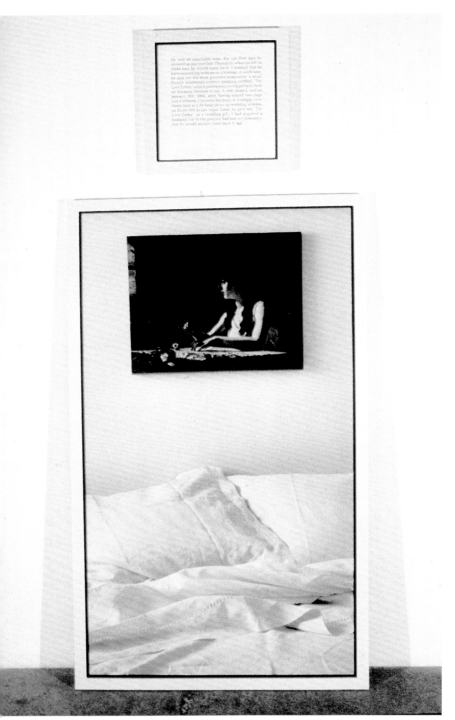

Sophie Calle, *Autobiographical Stories (The Hostage)*, 1992

*The Hostage.* He was an unreliable man. For our first date he showed up one year late. Therefore, when he left, to make sure he would come back, I insisted that he leave something with me as a hostage. A week later, he sent me his precious possession: a small French nineteenth-century painting entitled "The Love Letter," which portrayed a young girl who bore an uncanny likeness to me. A year passed, and on January 18th, 1992, after having rented two rings and a witness, I became his bride in a simple ceremony held at a 24-hour drive-up wedding window on Route 604 in Las Vegas. Later, he gave me "The Love Letter" as a wedding gift. I had acquired a husband but in the process had lost my guarantee that he would always come back to me.

*The Fake Marriage.* Our improvised roadside marriage in Las Vegas didn't allow me the chance to fulfill the secret dream that I share with so many women: to one day wear a wedding dress. So, on Saturday, June 20, 1992, I decided to bring family and friends together on the steps of a church in Paris for a formal wedding picture. The photograph was followed by a mock civil ceremony performed by a real mayor and then a reception. The rice, the wedding cake, the white veil—nothing was missing. I crowned, with a fake marriage, the truest story of my life.

*The Amnesia.* No matter how hard I try, I never remember the color of a man's eyes or the shape and size of his sex. But I decided a wife should know these things. So I made an effort to fight this amnesia. I now know he has green eyes.

*The Other.* There was a man I liked, but the first time we made love I was afraid to look at him. I thought I was still in love with Greg, and feared being overwhelmed by the idea that the man in my bed wasn't the right one. So, I chose to close my eyes. In the dark, at least the uncertainty remained. One day I made the mistake of telling him why I kept my eyes closed in bed. He said nothing. Several months later, finally free of the ghost of Greg, and my doubts, I opened my eyes, now certain that he was the one I wanted to see. I didn't know that it would be our last night together. He was about to leave me. "What happens is always so far ahead of us, that we can never catch up to it and know its true appearance."

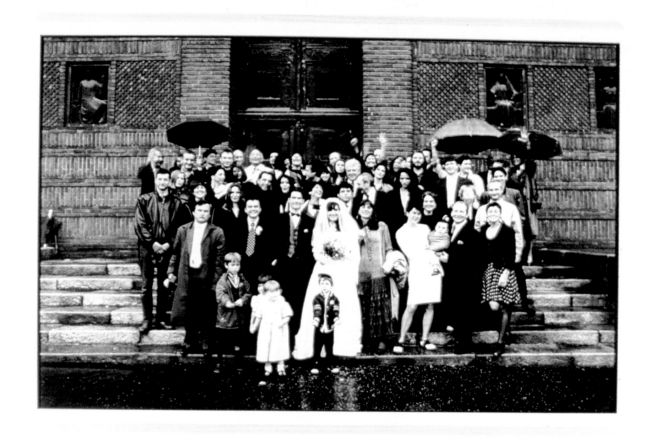

Sophie Calle, *Autobiographical Stories (The Fake Marriage)*, 1993

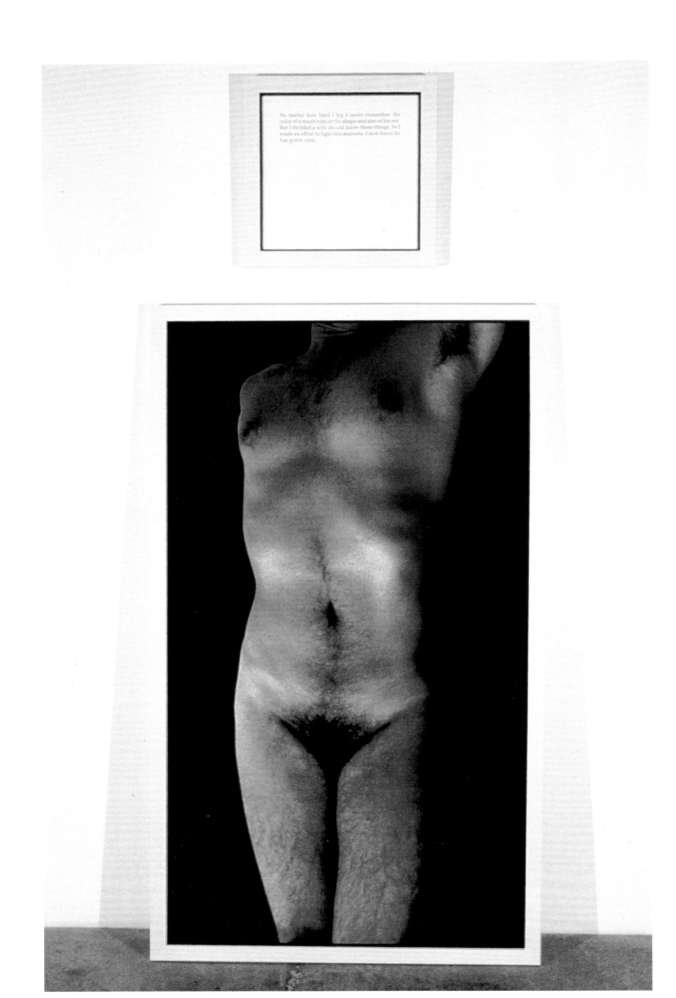

Sophie Calle, *Autobiographical Stories (The Amnesia)*, 1992

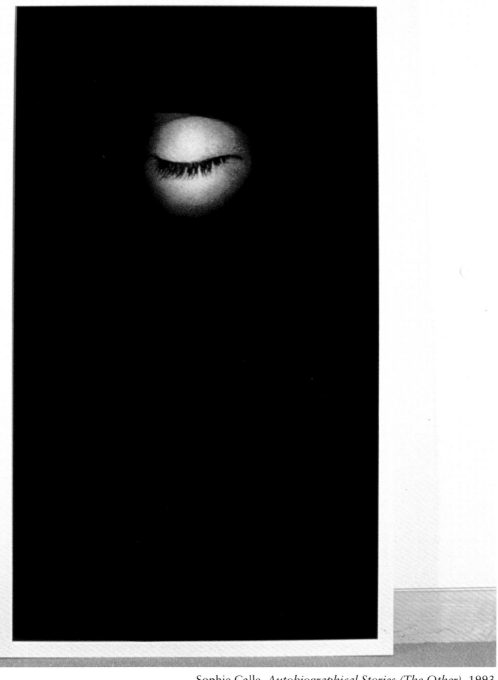

Sophie Calle, *Autobiographical Stories (The Other)*, 1993

# LOVE CHAMBERS

## PHOTOGRAPHS AND TEXTS BY BERNARD FAUCON

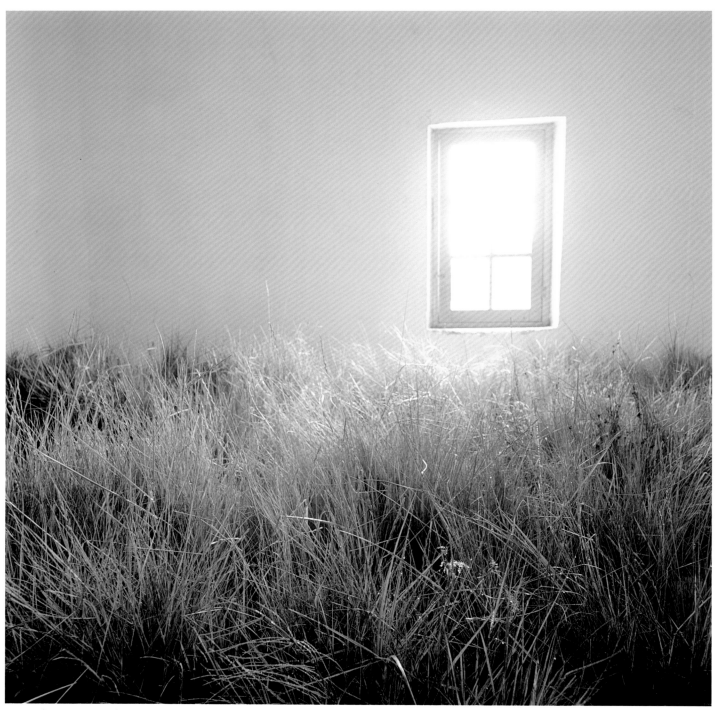

Bernard Faucon, *La douzième Chambre d'amour* (The twelfth love chamber), 1985

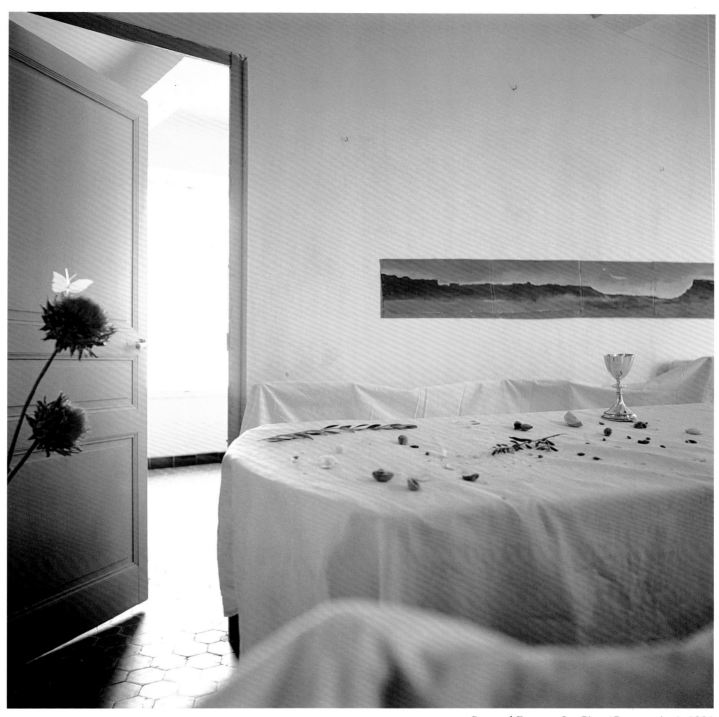

Bernard Faucon, *La Cène* (Communion), 1981

Age is bearing me away,
and the dream of love forces me to strive increasingly to return.
I lean out calmly over the abyss,
which reminds me of a pharaoh's burial chamber.
The shapes and colors of the bodies are unchanging, ash runs down the walls
and in place of the bed, I can make out an altar,
or a small boat.

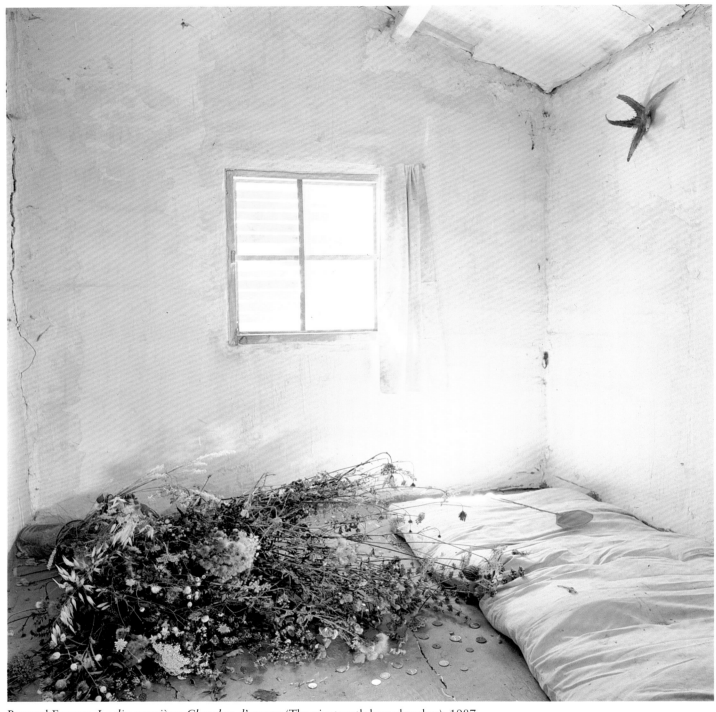

Bernard Faucon, *La dix-neuvième Chambre d'amour* (The nineteenth love chamber), 1987

*It is like waking from a short afternoon sleep.*

*You open your eyes, feeling a little numb, with a tightness around your temples*
*and your hair sticking to you slightly.*
*You are aware of your body and form a rough picture of it.*

*You recall your most recent thoughts and slowly return to full consciousness:*
*What have I done? I have aged, why did I forget myself?*

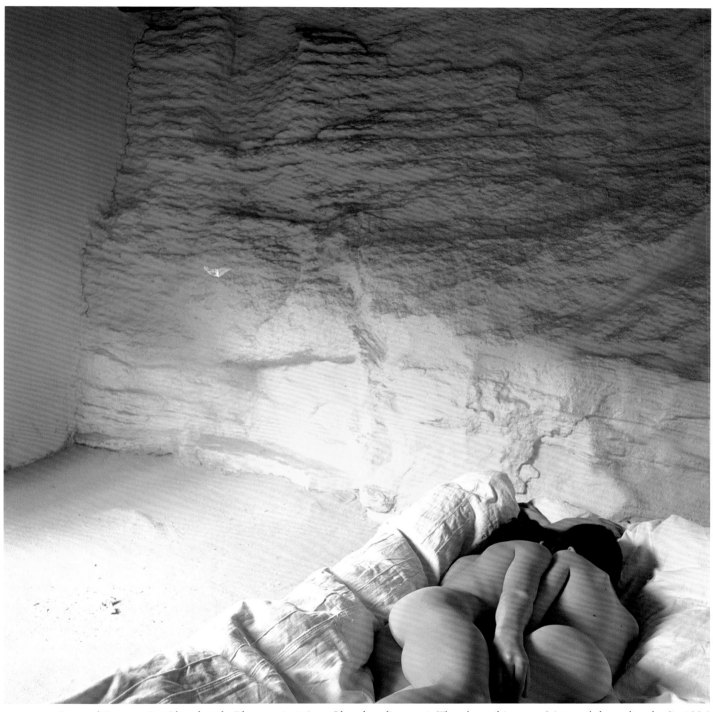

Bernard Faucon, *La Chambre du Pharaon (seizième Chambre d'amour)* (The pharaoh's room [sixteenth love chamber]), 1986

*The ideal object.*

*Nothing is more real*
*and at the same time more imaginary than the idea of love.*
*To photograph the emptiness of a love chamber*
*is to produce a fulfilment of existence*
*from the fusion of two gaps in existence*
*—the room and the photograph.*

# Evening

BY TRISTAN TZARA
PHOTOGRAPHS BY CAROLINE FEYT

*fishermen return with the stars of the waters*
*they pass out bread to the poor*
*thread beads for the blind*
*emperors stroll out into parks at this hour which is as*
    *bitter and precise as some old engraving*

*servants bathe hunting hounds*
*the light is putting on gloves*
*therefore shut the window*
*put out the light in your window as you would spit out the*
    *pit of an apricot*
*a priest from his church*

*good lord: weave soft wool for melancholy lovers*
*dip little chickadees in ink and clean the face of the moon*

*—let's catch beetles*
*and put them in a box*
*—let's go down by the riverside*
*to make earthen jugs*
*—let's hug*
*beside the fountain*
*—let's loiter in the public park*
*until cockcrow*
*and the town's up in arms*

*or in the granary*
*the hay prickles there we hear the cows moo*
*as they think about their little ones*
*let's make it*

Translated from the French by Charles Simic and Michael Benedikt.

Caroline Feyt, *Untitled*, from the series "Paysages" (Landscapes), 1990

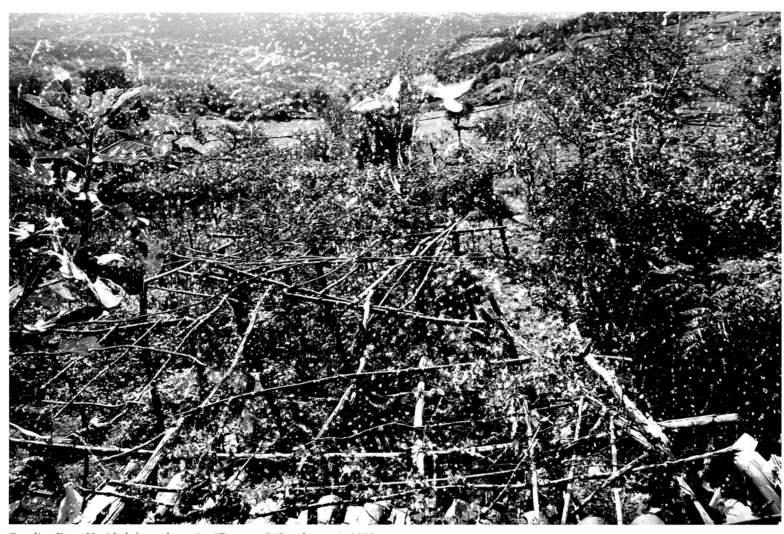

Caroline Feyt, *Untitled*, from the series "Paysages" (Landscapes), 1990

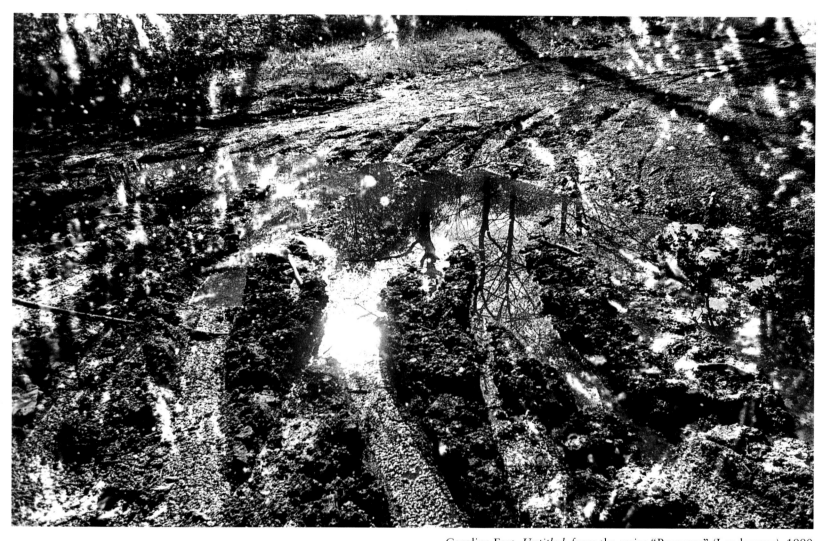

Caroline Feyt, *Untitled*, from the series "Paysages" (Landscapes), 1990

# THE LIGHT OF HOME

## PHOTOGRAPHS AND TEXT BY RAYMOND DEPARDON

I had the privilege of spending my childhood on a farm in the Sâone Valley, in the center of France. Rural French life has undergone enormous changes during the course of this century.

Now, I am trying to return to the farm of my childhood, to the light, the hard work, the importance of the sky, the life and the habits of my parents.

If I pay attention to my memories, I see only the joys of playing in the hayloft, the happiness of running along the little paths around the farm; I see an enchanted world, filled with animals—as beautiful as childhood. But I know that it was also a hard world, poor, without comforts, in which my parents worked every day except Sunday from daybreak until dark.

I was a child—too young to photograph that universe, which is now disappearing. But in certain regions of France, there are still farms . . . which are in the process of dying. I have to work quickly.

My father was born in the same year as Walker Evans, and he died at the same age. And Walker Evans has helped me to look around at my childhood—that country world of the past and of the present.

My childhood has saved me: I owe everything to it. I have traveled the world, but still I come back here. I must continue this work, so that I do not forget my roots, so that I do not exorcize that pain.

Happily, there is one thing that has not changed: the light.

*Translated from the French by Diana C. Stoll.*

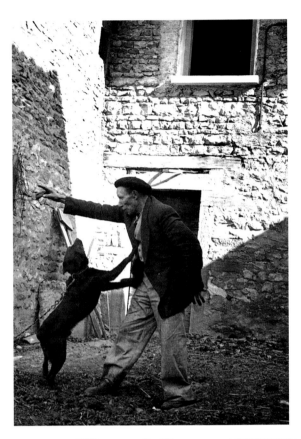

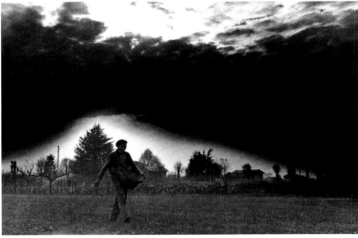

*Top*: Raymond Depardon, *Le Sylvestre, ouvrier agricole de mon père, avec le chien Pernod* (Sylvestre, my father's farmhand, with the dog Pernod), Ferme du Garet, 1956

*Above*: Raymond Depardon, *Sylvestre semant* (Sylvestre sowing), Ferme du Garet, 1956

*Left*: Raymond Depardon, *La cuisine de mes parents* (My parents' kitchen), Ferme du Garet, 1956

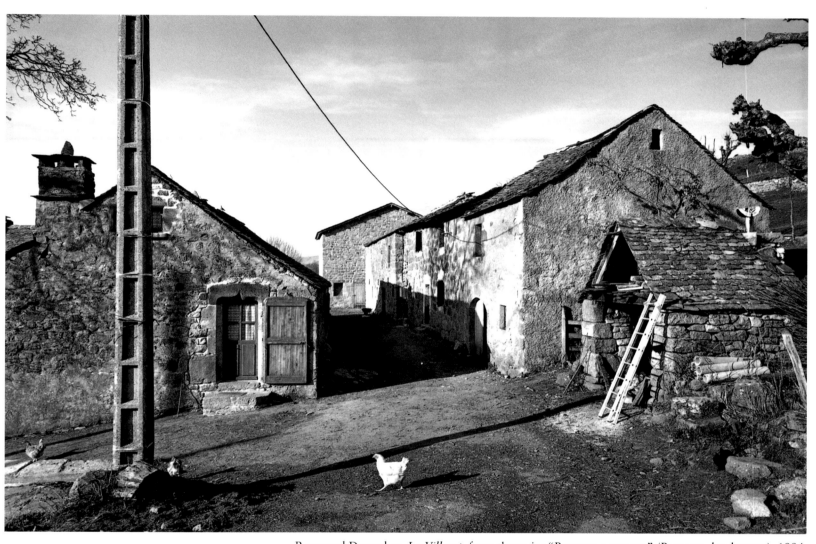

Raymond Depardon, *Le Villaret*, from the series "Paysans, paysages" (Peasants, landscapes), 1994

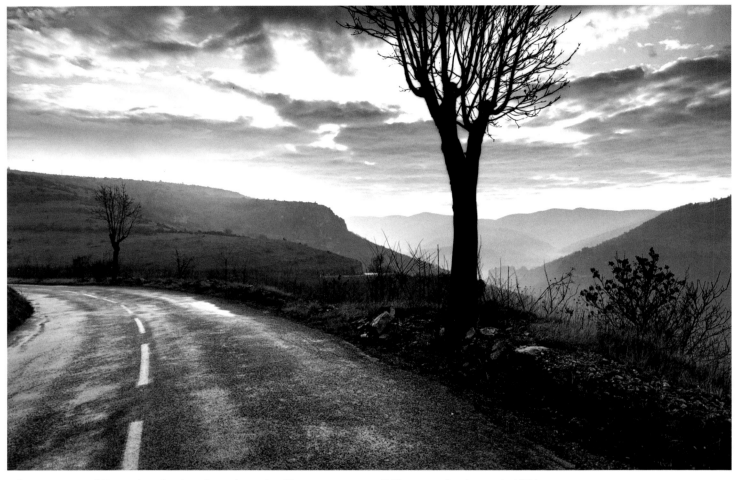

*Above*: Raymond Depardon, *Lozère*, from the series "Paysans, paysages" (Peasants, landscapes), 1994
*Below*: Raymond Depardon, *Marcel Privat*, from the series "Paysans, paysages" (Peasants, landscapes), Villaret, Lozère, 1994

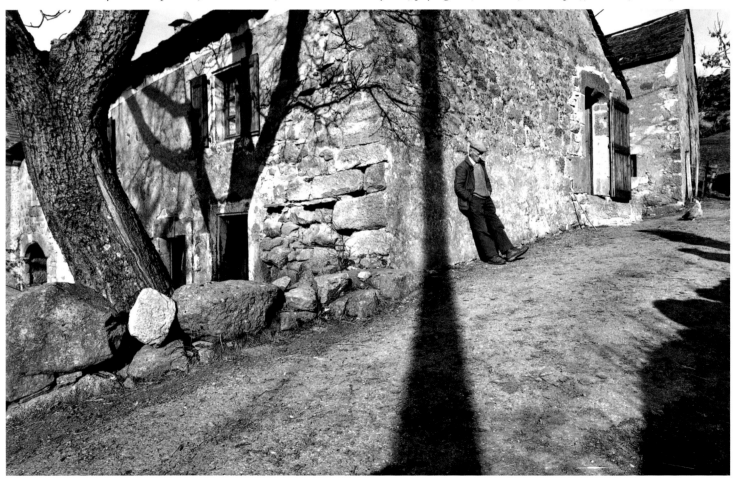

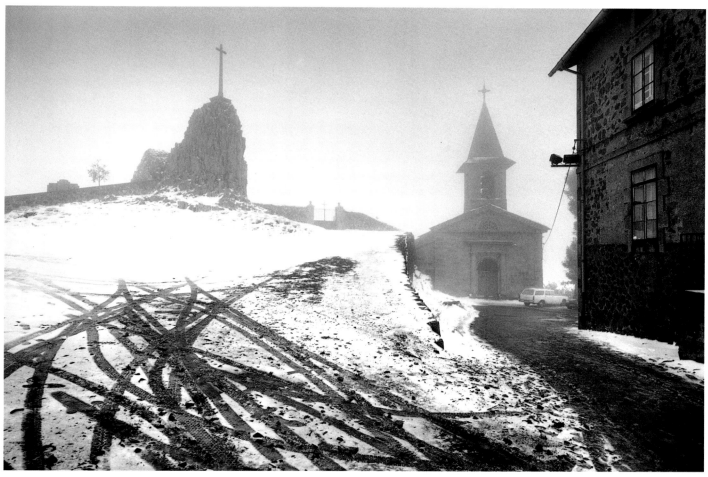

*Above*: Raymond Depardon, *Calvaire*, Fay-sur-Lignon, Haute-Saône, 1994; *Below*: Raymond Depardon, *Madeleine Lacombe*, *retraitée agricole* (Madeleine Lacombe, retired farm worker), Dordogne, 1994, both from the series "Paysans, paysages" (Peasants, landscapes)

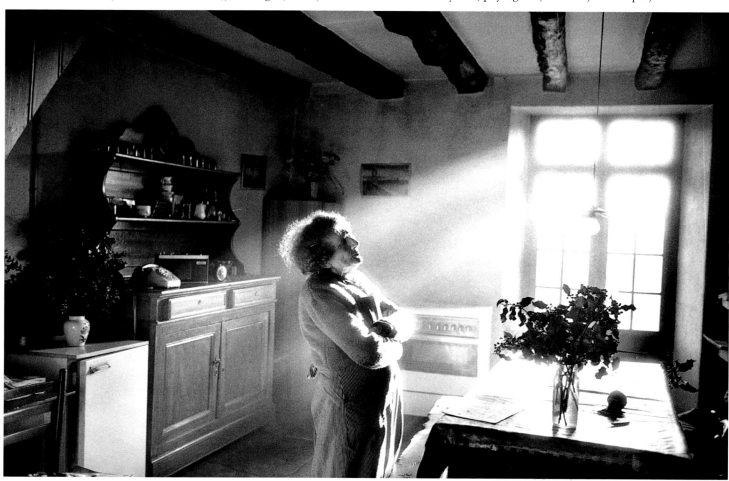

# TWO-WAY MIRRORS

## BY XAVIER EMMANUELLI
## PHOTOGRAPHS BY JEAN-FRANÇOIS JOLY

Like the sort of fishing that consists of letting lines drop to the bottom of the sea and then collecting all the fish that are caught, in a heap, netting them with the simple movement of the boat—the recruitment of Paris's advocates for the homeless is a kind of trawling. Their cars and those of the Paris trains bring people out of the depths, collected from the metro and other traditional gathering places—train stations, the portes de Paris, Maubert, Châtelet, Les Halles—men and women emitted from the pits of the city.

At first, they seem unwilling, but then, either from sheer exhaustion, or else animated by some obscure hope of assistance—without even being able to articulate it—they come to this encounter from their miserable buses, driven by policemen who are more sympathetic than coercive, to seek temporary comfort, or just an ear when they feel at the end of their resources.

Their lesions bear witness to their abandonment. Those who can no longer ask with their mouths show with their skin the marks of their battles and revolts, the efforts that have brought them down, level by level, to each new degree of exclusion, arriving finally at the last phase of vagrancy. Their old tattoos are illustrated alphabets of vengeance, love, religion; they manifest the loss of something—a companion, a mother—or for some encounter that they wanted to hold onto, their dreams of adventure with sirens, tigers, birds and setting suns, engraved on the epiderm. . . . Their giant ulcers—always neglected, infected—speak with rage or dispassion of the rejection of a body too heavy, too ugly, or too cumbersome, that alienates them by appearance and by odor. Their scabies, lice, eczema, and psoriasis, their funghi and eruptions all express the turmoil and the contrarinesses of the organism.

In order to survive, all that is left to them is a grotesque of poses—mimicking social gestures like clowns—and the pathetic mischief of a few tricks for soliciting alms: putting forth a hand that no other hand can shake, and into which we place at most a few cents—soon transfomed into alcohol, which dilutes the burdensome consciousness and dissolves hard reality into a diminished and stupefied "here and now," without hope and without future, the scattered ruins of humanity. . . .

These *exclus* ("excluded ones"—to use a recent appelation), the salt of the earth, bring our sense of comfort back to a more relative appreciation: through them, we are able to think just a little bit about others when we come across them, if we perceive them. But most of the time, as they disturb our gaze and make us ill at ease, we do not perceive them . . . they are invisible.

And yet they are best that way, these people so reduced, endlessly crossing our paths, pointing out our mortal condition. They are more than anything sufferers, although their suffering is often silent.

We must look at them with compassion, with humility, as they are not asking to be cured, they know well that you can't be cured of this fatality; they are only looking for warmth, consideration. . . .

Plainly, hospitals were not made for these people; hospitals no longer allow for simple compassion—this requires time, know-how, patience, and reassuring words of trust and humanity. There is only time for emergencies, triage, specific diagnoses—but this doesn't concern these people: they long ago gave up on the integrity of their bodies. If one had to find a common point among these abandoned men and women, it is not in their way of life, it is rather in their *break* from it, from the image of an integral body. They are no longer able to evaluate their own state of health—which means that they cannot tell whether they are sick or not, if they are in danger or not . . . they have constructed themselves, ignoring and scorning themselves, as they have been ignored and scorned. Bit by bit they have become separated from their own image.

They cannot go to a restaurant, to a café, to a movie; they cannot loiter anywhere, on any bench. They are undesirable, even in the hospital, where their repulsive looks, their garbled, husky discourse, prevent attentive examination, and they are quickly shown the door. So even their pain cannot be taken into account.

And when we do look with tenderness or compassion upon these beings, misled by destiny, conquered by the fatality that has overtaken them, then we ourselves become *exclus*. In others' eyes, those who take care of these poor wretches are considered marginal or militant do-gooders. According to an old adage, "a doctor of paupers equals a pauper doctor"—a doctor worthy of his name would not accept such a clientele.

These men and women, bruised, wounded, ignored, must be reached with diligence and competence, with attention and respect: their great lack is not material—these people suffer more than anything from a lack of love. If we love them a little, they might love themselves; this is why the cure for exclusion doesn't really lie in a social plan, it lies much deeper, in the secret place of our heart, in the looks we give to one another, in tenderness and compassion.

*Translated from the French by Diana C. Stoll.*

*Excerpts from "Les Miroirs sans tain" by Xavier Emmanuelli, from* Naufragés de la ville, *Paris: Contrejour, 1994. Translated and printed by permission of the author.*

Jean-François Joly, *page 37*: *Sans Domicile Fixe, Huguette, 58 ans* (Homeless, Huguette, 58 years old), CHAPSA, Nanterre, spring 1994; *page 38*: *Sans Domicile Fixe, Huguette, 57 ans* (Homeless, Huguette, 57 years old), CHAPSA, Nanterre, summer 1993; *page 39*: *Sans Domicile Fixe, Thérèse, 52 ans* (Homeless, Thérèse, 52 years old), CHAPSA, Nanterre, winter 1994

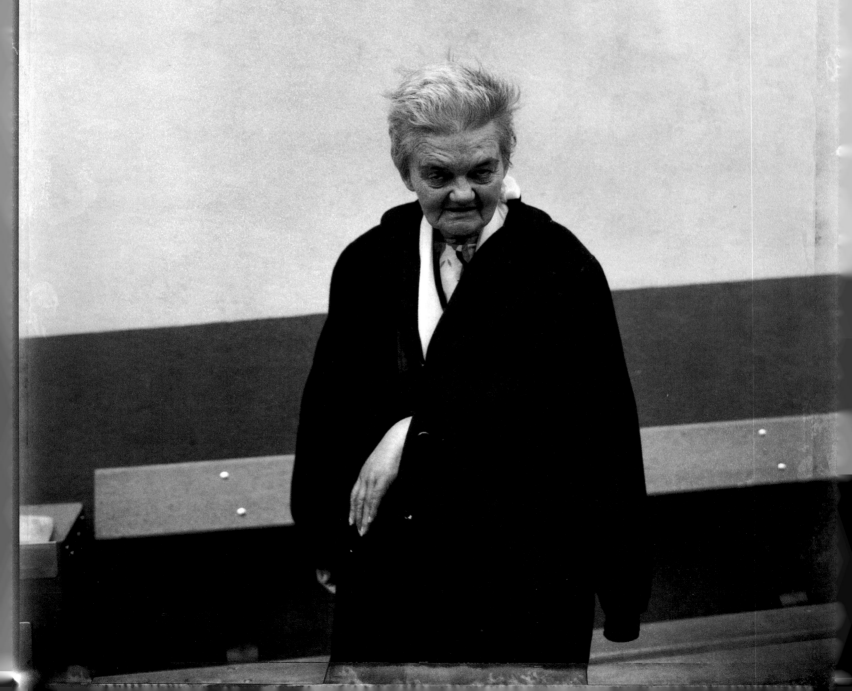

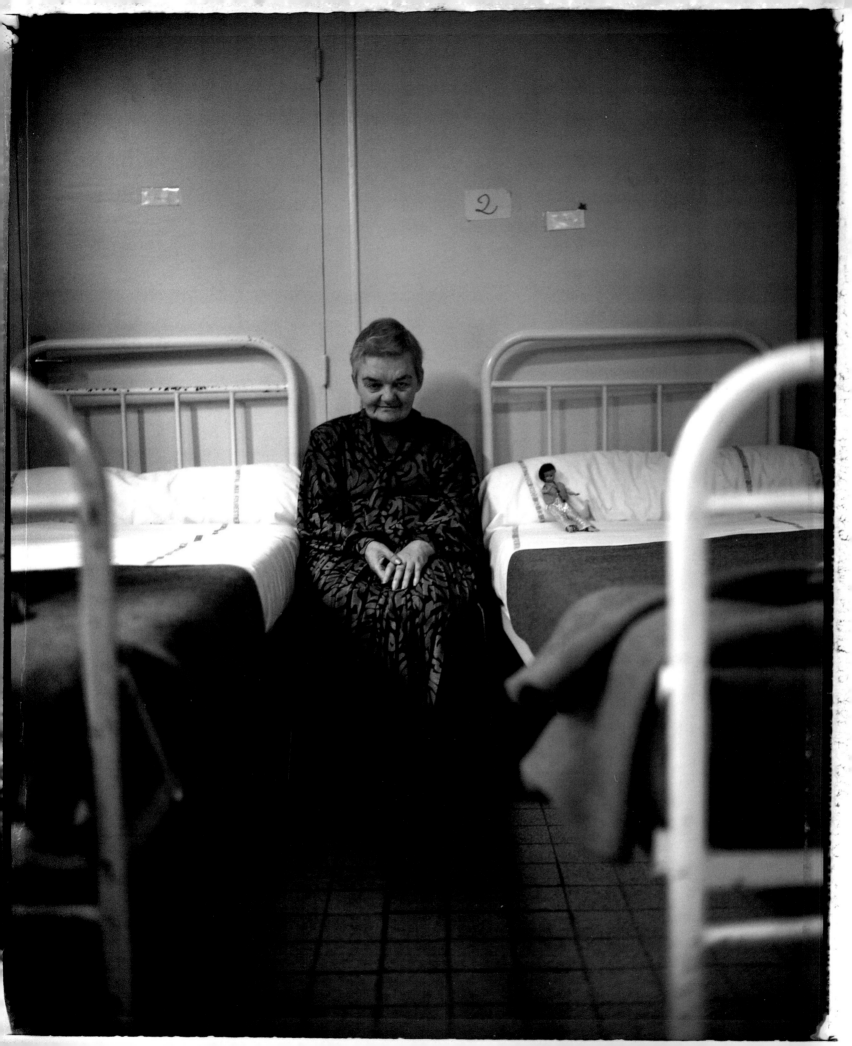

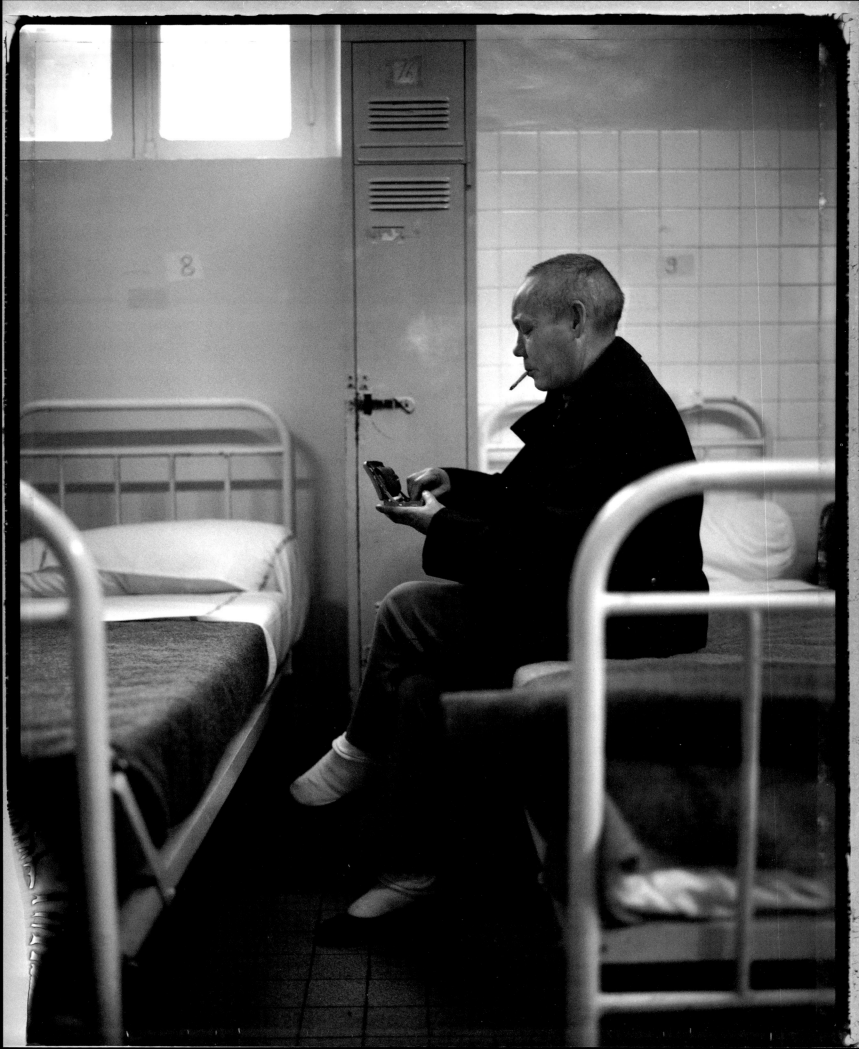

# UPROOTED LIVES: FRANCE'S "NEW POVERTY"

## PHOTOGRAPHS AND TEXT BY MARIE-PAULE NÈGRE

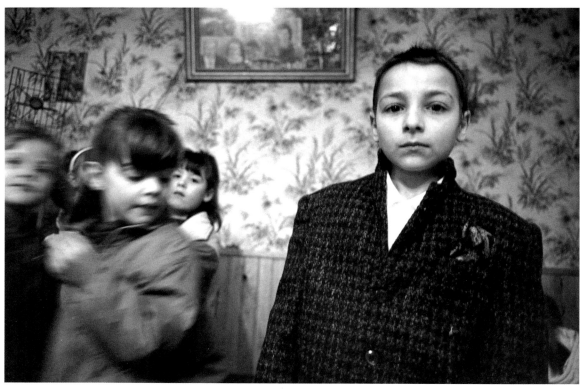

Marie-Paule Nègre, *A Tale of Modern Times, or, Everyday Poverty*, Dijon, 1988

In the early eighties, following the recession, economic changes such as increased automatization, new attention to Third World countries, and the massive inflation of the seventies, many Western countries witnessed the appearance of a phenomenon they believed had long since been eliminated: the growth of poverty.

In 1984 in France, the Salvation Army reintroduced the soup kitchens it had done away with fifty years before. The number of homeless persons multiplied. The crowds who suddenly appeared, hands outstretched, in welfare centers and charity organizations were baptized the "nouveau pauvreté." It was not until 1988 that the French parliament voted almost unanimously to establish a guaranteed minimum income of 2,000 francs per month to those who requested it. Five years later, almost 600,000 French people were receiving this survival wage.

It is both paradoxical and scandalous that this class of poor people exists within our rich, modern societies. Yet, because the majority of them—except for the alcoholics, dropouts, and homeless—are invisible to our eyes, they arouse only a vague guilty conscience in those of us who are not suffering with such need.

I went to see some of these ordinary people: people who had been struck with job loss, uprooted lives, broken families, and illness; the people we do not notice in the street, whom we leave in the hands of professional philanthropists, and whom perhaps we do not wish to know.

You need only to push open the door and enter their homes to discover another universe. At first glance, everything seems quite normal: no obvious outward sign of poverty. Then, you begin by noticing that there is some small detail wrong. A missing tooth. A look that is too empty. A laugh that is close to hysteria. You realize they almost never leave their homes, that they stay together, crammed into their closed universe, talking for hours and touching each other as if for reassurance, inventing games, inventing hopes. Fearful of the world outside, they kill time waiting—for God knows what. You need to kill some of this time with them in order finally to catch a glimpse, behind a gesture or a look, of their emotion, their frailty, and the deep anguish that is their day-to-day existence.

*Translated from the French by Karin Lundell.*

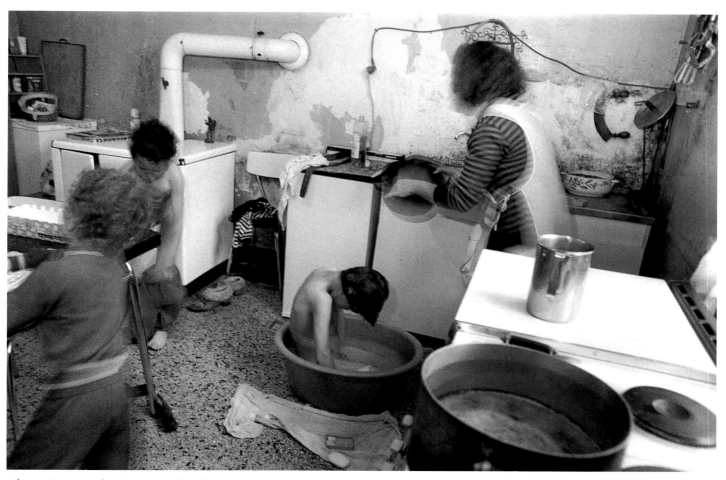

*Above*: Marie-Paule Nègre, *A Tale of Modern Times, or, Everyday Poverty*, Reims, 1988
*Below*: Marie-Paule Nègre, *A Tale of Modern Times, or, Everyday Poverty*, Villefranche-sur-Saône, 1988

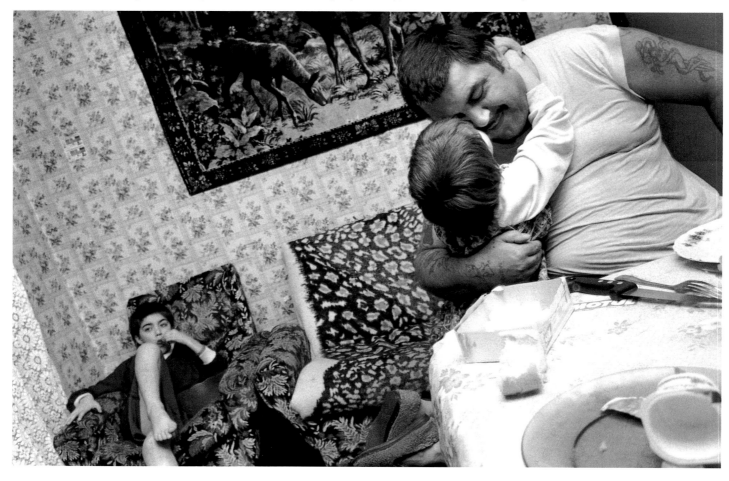

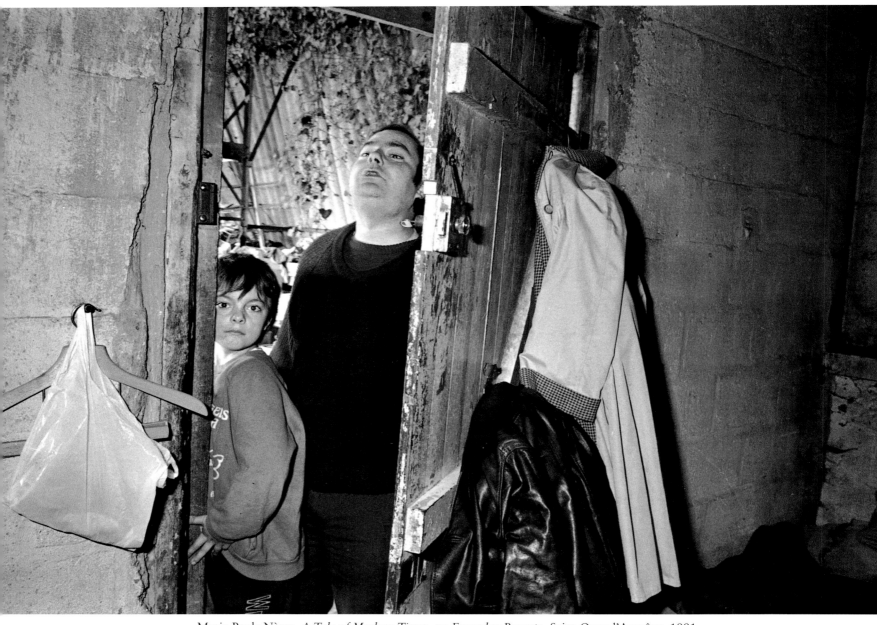

Marie-Paule Nègre, *A Tale of Modern Times, or, Everyday Poverty*, Saint-Ouen-l'Aumône, 1991

At first glance, everything seems quite normal:
no obvious outward sign of poverty. Then, you begin
by noticing that there is some small detail wrong. A missing
tooth. A look that is too empty. A laugh that is close to hysteria.
You realize they almost never leave their homes, that
they stay together, crammed into their closed universe. . . .

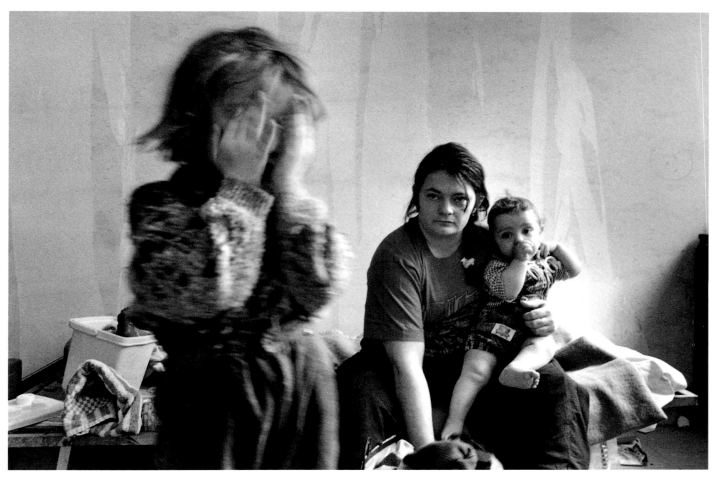

*Above*: Marie-Paule Nègre, *A Tale of Modern Times, or, Everyday Poverty*, Les Ulis, 1991
*Below*: Marie-Paule Nègre, *A Tale of Modern Times, or, Everyday Poverty*, Saint-Ouen-l'Aumône, 1991

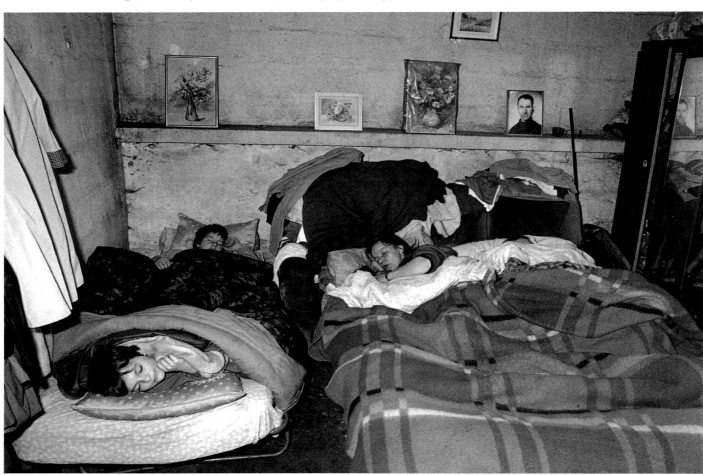

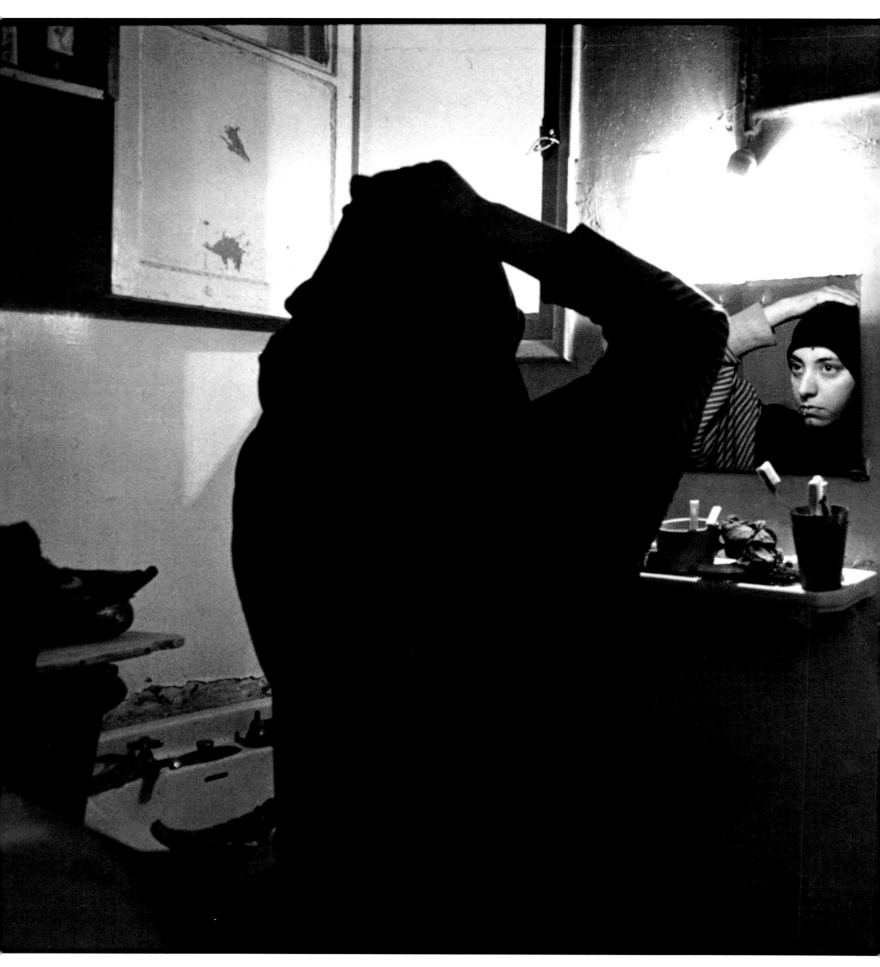

# VEILED DESTINIES: WOMEN IN ALGERIA

## PHOTOGRAPHS AND TEXT BY NADIA BENCHALLAL

I am profoundly linked to the women of Algeria and Kabylia by my ethnic origins as well as by the bonds created within my Algerian family. I am, however, well aware of the divergence of my own destiny from that of these women. I want to bear witness to the fact that behind each veil, there is a woman whose personal desires and capabilities are intricately woven within the history and the future of her country. I want to reveal the struggle of these women against a patriarchal regime and its political and social institutions, which deny them recognition. Algeria is a country where woman is compulsorily anonymous: by law, she is a specter.

Algerian women very often live within an extended family environment comprised of mother-in-law, sisters-in-law, and the flock of children in whom they place all their hopes and dreams. The women are for the most part homebound and illiterate, with no avenue of escape to the outer world other than the occasional family visit or the daily task requiring them to leave the household.

In the presence of these women I reflect upon others who have left their mark on this country's history: La Khanine, the revolutionary leader who fought the Arab invasion in the seventh century, and more recently, Djamila (or Fatima), who participated in the war of independence.

Women of strength and conviction exist also in today's conflict. In contemporary Algeria's hostile society, these women have achieved their goals and will defend their positions against all obstacles.

Nadia Benchallal, Karima readjusts veil before going out, Algiers, Algeria, 1995

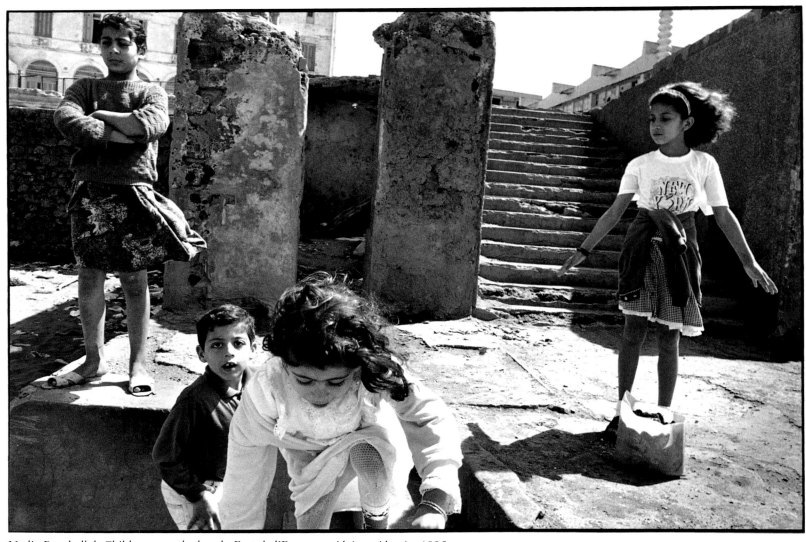

Nadia Benchallal, Children near the beach, Fort de l'Eau, near Algiers, Algeria, 1995

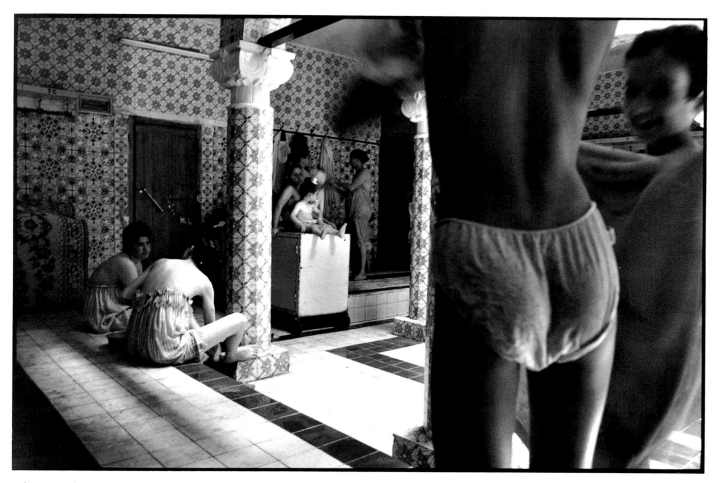

*Above*: Nadia Benchallal, Women, Algiers, Algeria, 1995
*Below*: Nadia Benchallal, Unveiled aunt ending discussion with niece in the staircase, Algiers, Algeria, 1995

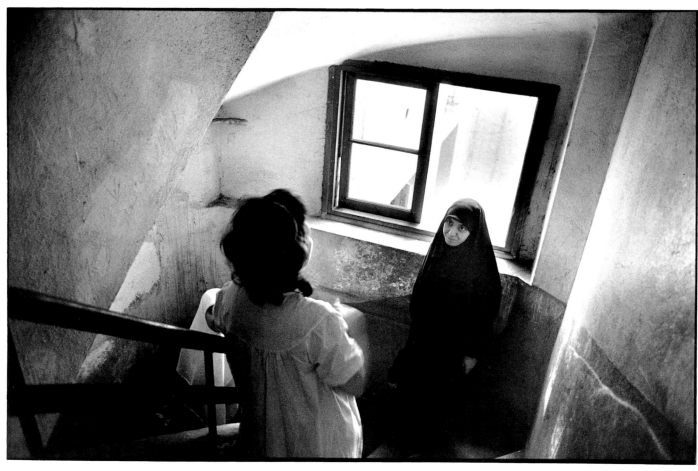

# NO PITY FOR SARAJEVO

BY JEAN BAUDRILLARD

PHOTOGRAPHS BY JEAN-CLAUDE COUTAUSSE

Recently Susan Sontag came to direct *Waiting for Godot* in Sarajevo. Why not *Bouvard et Pecuchet* in Somalia or Afghanistan? But what is worst is not this extra portion of cultural soul. It is, rather, the condescension and error of judgment with regard to force and weakness. It is they who are strong, it is we who are weak—and who go searching in their lands for what it takes to regenerate our weakness and our loss of reality.

Our reality: therein lies the problem. We have only one reality, and it is necessary to save it. Even by adopting the worst of slogans—"Something must be done. One can't simply do nothing." Whereas to do anything whatever for the sole reason that one cannot do it has never constituted a principle of action, or of liberty. This is a precise form of absolution for one's own impotence and of compassion for one's own fate.

In their situation, [the people of Sarajevo] have the absolute necessity to do what they are doing, to do what they must. Without illusion regarding the outcome, without compassion for themselves. It is in this that they are being real, in this that they have plunged into the real. . . .

That is why it is they who are alive, and it is we who are dead. That's why we need, first of all, in our own eyes, to save reality from the war and to impose, in some form, this (compassionate) reality on those who are plunged within it but who, at the very heart of the war and of distress, do not truly believe in this reality.

One must go where the blood flows in order to refashion one's reality. All these "corridors" which we [Europeans and Americans] open in order to export to them our food and our "culture" are in reality corridors of distress through which we import their vital forces and the energy of their misfortune. One more unequal exchange.

Susan Sontag herself is not responsible. She is simply a fashionable illustration of an otherwise general situation, in which inoffensive and impotent intellectuals exchange their misery for that of the miserable, each supporting the other in a sort of perverse contract—just as the political class and civil society today exchange their respective miseries, the one offering its fodder, its corruption and its scandals, the other its artificial convulsions and its inertia.

Our entire society thus enters onto the path of "commiseration" in the literal sense, under the cover of ecumenical pathos. It is as though, in a moment of immense repentance among intellectuals and politicians, linked to the panic of history and the twilight of values, it was necessary to restock the hatchery of values, the hatchery of references, by appealing to the lowest common denominator—which is the world's misery, to restock the hunting grounds with artificial game. "Currently it is impossible, on news programs, to televise any spectacle other than that of suffering" (David Schneidermann). Victim society. I suppose that this term expresses only society's disappointment with itself and its remorse at an impossible violence against itself.

Everywhere, the New Intellectual Order follows the open paths of the New World Order. Everywhere the misfortune, the misery, the suffering of others have become the primary material and the primordial scene.

All commiseration is in the logic of unhappiness. To refer to it, even if it is to combat it, is to give it a base for indefinite objective reproduction. In any event, in order to combat no matter what, one must begin from evil, and never from unhappiness.

And it is true that the theater of the transparency of Evil is indeed there, in Sarajevo. The repressed canker which rots the rest, the virus of which European paralysis is already a symptom. . . . The ghost Europe, the unfindable Europe, the jerry-built Europe in its most hypocritical convulsions, fails utterly at Sarajevo. And in this sense, the Serbs serve almost as the instrument of demystification, as the savage analyzer of this phantom Europe, this Europe of techno-democratic politicians as triumphal in their discourse as they are enfeebled in their actions. For one sees clearly that Europe degrades itself even as the discourse on Europe blossoms (as one sees clearly that the rights of man are debased as the discourse on the rights of man proliferates).

*Above*: Jean-Claude Coutausse, Growing vegetables, Marijn Dvor district, Bosnia, Sarajevo, 1994
*Below*: Jean-Claude Coutausse, Woman washes her windows, Skenderija district, Bosnia, Sarajevo, 1994

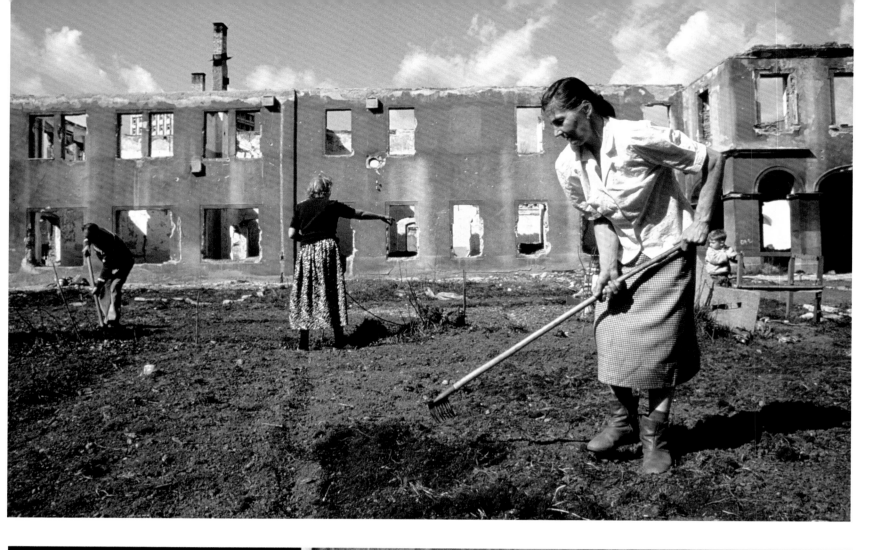

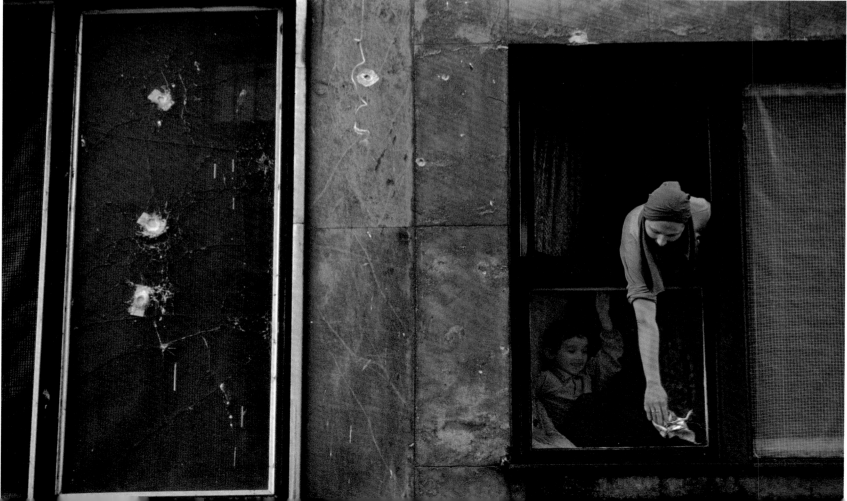

Jean-Claude Coutausse, Merchant on Marshal Tito avenue, Bosnia, Sarajevo, 1994

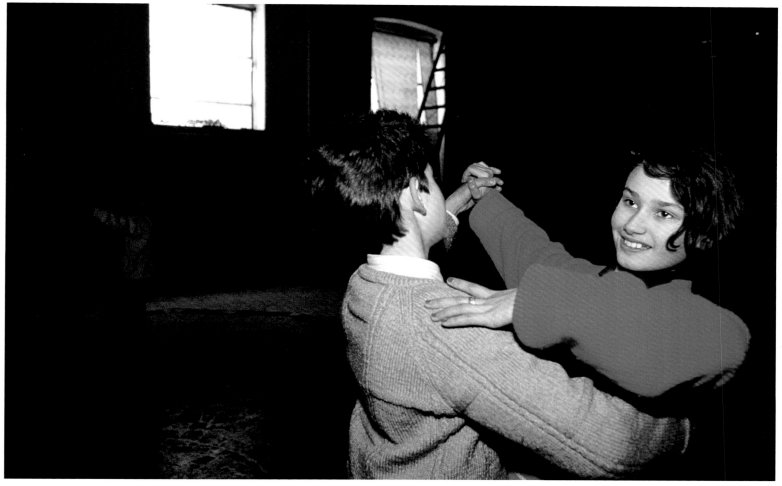

Jean-Claude Coutausse, Acrobatic dancing lesson, Bosnia, Sarajevo, 1994

But in fact, this is not the last word in this story. The last word is that the Serbs, insofar as they are the carriers of ethnic cleansing, are the narrow edge of that wedge into which Europe is creating herself. For "real" Europe is in the process of creating herself as White Europe. Whitened Europe, integral and purified—morally, economically, or ethnically. She is in the process of creating herself victoriously at Sarajevo, and in this sense, what happens there is not at all an accident on the highway of a nonexistant Europe, pious and democratic; it is a logical and ascendant phase of the New European Order, subsidiary of the New World Order, which is everywhere characterised by "white" fundamentalism, protectionism, discrimination, and control. We say: if we let this happen at Sarajevo, we have every right to expect it to happen to us also, as a consequence. But we are already there.

It is as if Europe, all nationalities reunited, all policies jumbled together, had put out a "contract," a contract of killers, with the Serbs as the executioners of Europe's dirty look—just as the West previously had contracted with Saddam Hussein against Iran. Sim-

ply put, when the hit man goes too far, it eventually becomes necessary to eliminate him also. The operations against Iraq and Somalia were relative failures, from the point of view of the New World Order, that of Bosnia seems on the road to success from the point of view of the New European Order.

The people of Sarajevo, on the [television] screen, certainly had the air of being without illusion and without hope, but they did not have the air of being potential martyrs, very much to the contrary. They had, to their credit, their objective misfortune, but the true misery, that of the false apostles and voluntary martyrs, was on the other side. Now, as they (quite accurately) say, "voluntary martyrs will be of no account in the beyond."

*Translated from the French by William La Riche.*

*Excerpts from "Pas de pitié pour Sarajevo" by Jean Baudrillard, from* Libération, *January 7, 1993. Translated and printed by permission of the publisher.*

# WAR AND DREAMS

## PHOTOGRAPHS AND TEXT BY CHRISTINE SPENGLER

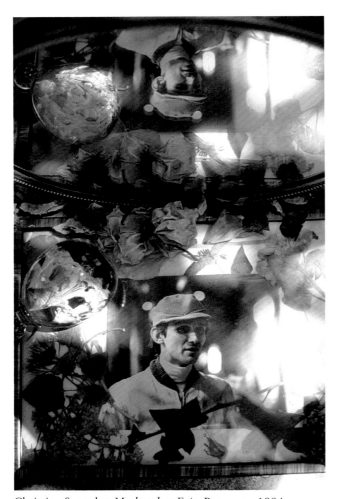

Christine Spengler, *My brother Eric*, Provence, 1984

After my beloved brother Eric committed suicide, in 1973, I wanted to die in a dark road of Lebanon. For ten years I dressed, dreamt, and photographed in black-and-white—the mourning of the world: Vietnam, Cambodia, Lebanon, Iran, Nicaragua, El Salvador. . . . But the only place in the world that frightened me was Alsace, in my own native country, in France, because there was a little cemetery there that showed a name I didn't want to see—Eric.

Then, I made a pilgrimage to Eric's tomb, and I accepted the reality of his death—the light came back. Remembering the "Cemeteries of the martyrs" in Iran, I decided to create an homage to my family. I surrounded portraits with "souvenir objects": pearl necklaces, feathers, sand, pieces of broken mirror, candles. . . . When I left, at night, the little cemetery of Mulhouse looked like a Bolivian grave. . . .

Later, I took all those portraits with me and displayed them in my hotel rooms at the ends of the world, just as the bullfighters do with their "macarenas"—their "weeping virgins." The people in the portraits looked so alive that I forgot they were dead. A second life began then for me, far from the tragedy.

In these little "altars" I put all the color, the fantasy, and the surrealism which I had forbidden myself for so many years. In 1982, after my arrest in Beirut, I decided that for every picture of grief and horror I took in my life, I would expose its counterpoint in beauty. All my work now is an homage to color and life. I have torn the black dresses of the war days into colored gowns, and now I wear roses in my hair. . . .

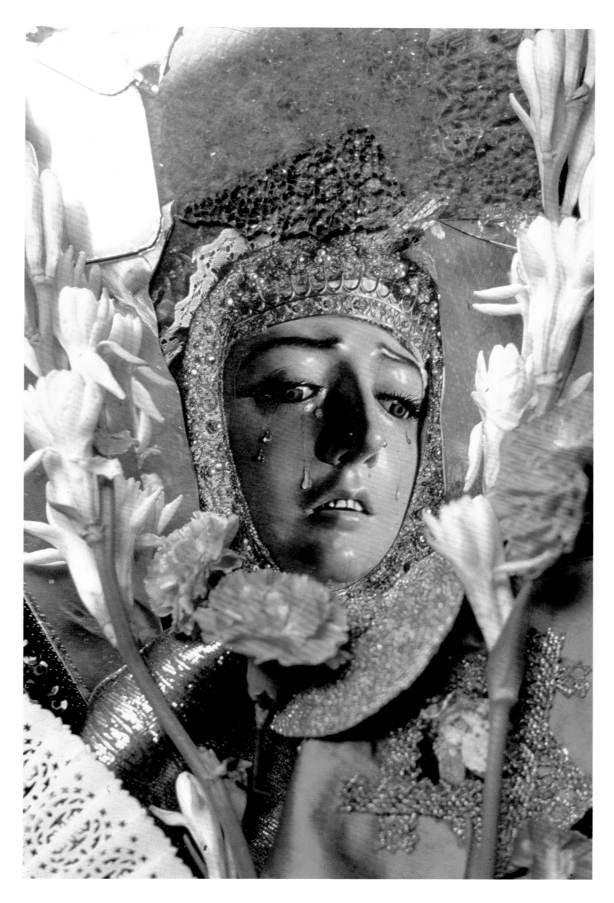

Christine Spengler, *Weeping Virgin*, Seville, 1987

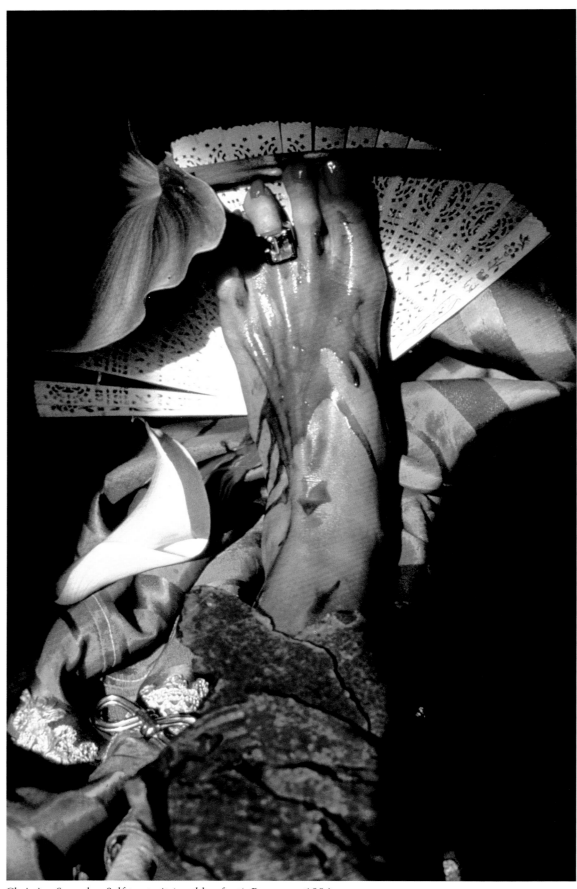

Christine Spengler, *Self portrait (my blue foot)*, Provence, 1984

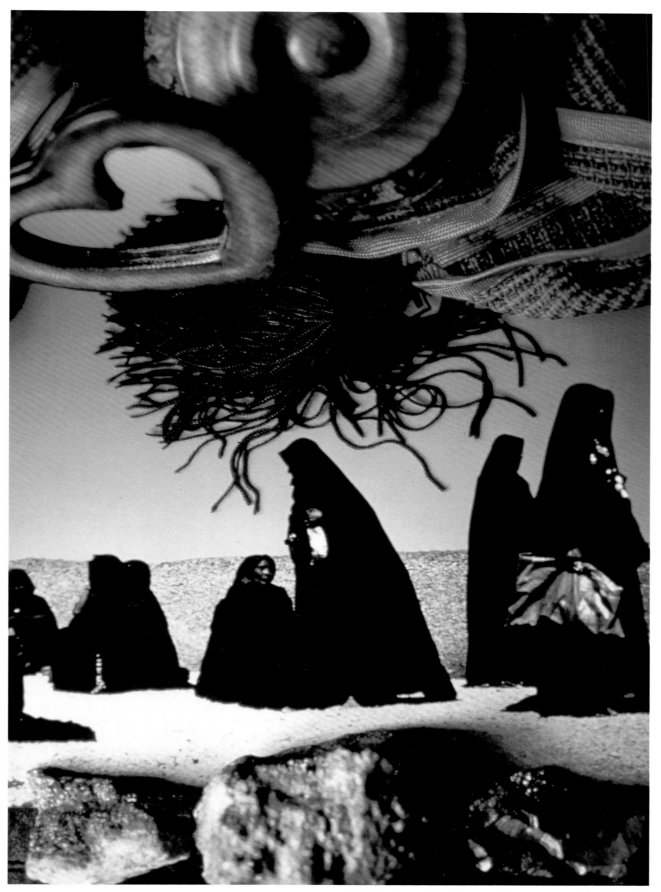

Christine Spengler, *Heaven in Tamamrasset*, Algeria, 1984

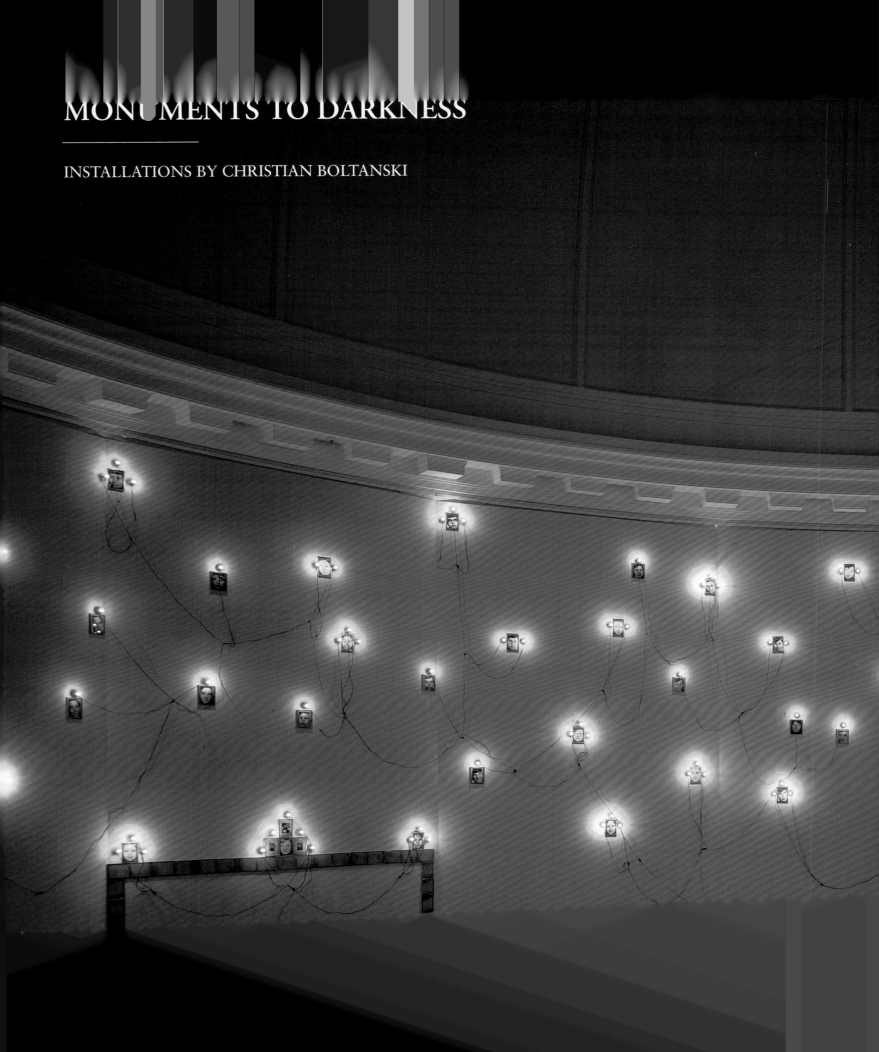

# MONUMENTS TO DARKNESS

## INSTALLATIONS BY CHRISTIAN BOLTANSKI

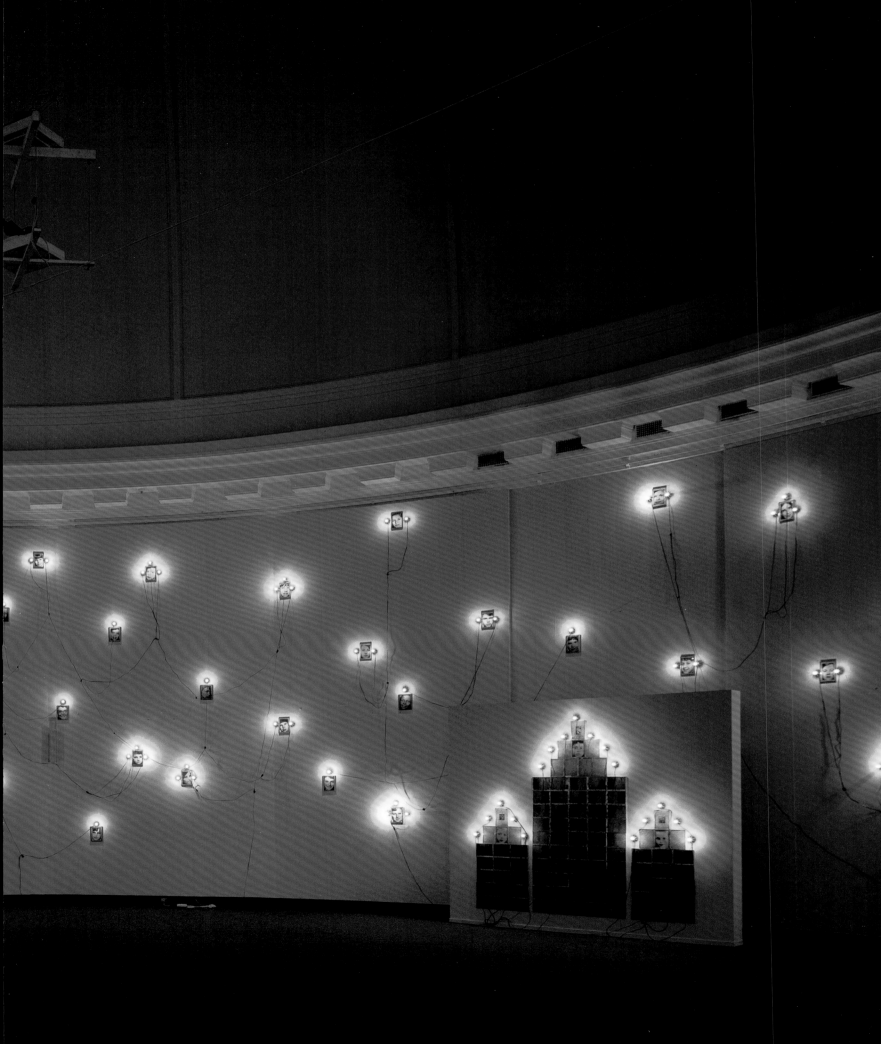

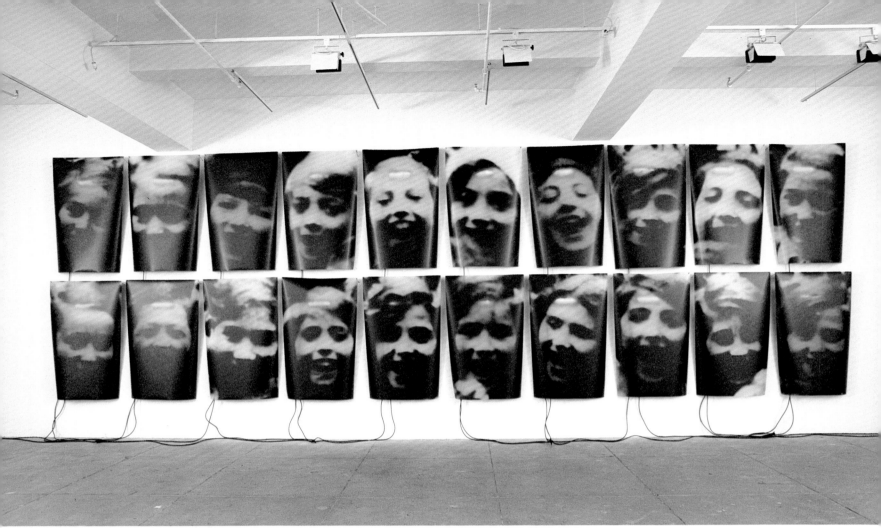

*Pages 56–57*: Christian Boltanski, *Inventar with Monuments: Les Enfants de Dijon and Monuments*, 1991

*Above*: Christian Boltanski, *Jewish School of Gosse, Hamburgerstrasse in 1938*, 1994

*Opposite*: Christian Boltanski, *Jewish School of Gosse, Hamburgerstrasse in 1938*, 1994

Christian Boltanski has over the course of his career developed a highly personal and sometimes troubling oeuvre, which frequently puts to the test basic assumptions about what constitutes an artwork. His media range from the mundane (newspaper clippings, used clothes, and amateur snapshots) to the ephemeral (flickering shadows, his own utterly elusive life story). He is probably best known for his profoundly disquieting installations relating to the Holocaust.

Boltanski's connection to photography is complex. He has spoken of his own Jewish heritage and its contradictions as having affected his choice to use photography in his art: "A strange relation to the divine, the feeling of being simultaneously part of the 'chosen' and the least of men, has driven me to affirm then contradict myself. . . . In Jewish culture, I'm drawn to the fact that one says one thing and its opposite at the same time. . . . I imagine that my ambiguous relationship with painting and my use of photography are linked to this Jewish consciousness, if I so much as have one. I do photography, considered a less noble art than painting, as if I were afraid to confront this very sacred art."[1]

Boltanski's numerous series on themes of the Holocaust are pointedly tragic, elegiac. His use of ordinary photographs within them reminds us of a fact about the medium: we are permitted to look at people in photographs with a prolonged intensity and an intimacy that we otherwise reserve only for extreme emotional states, such as love, or charged situations, such as a final parting. And yet these are more than ex votos: they are works of art. This disparity adds a new level of complexity to these images.

Boltanski has said, "One of the subjects that interests me is the transformation of the subject into object. A whole section of my work centers on this idea—for example, my interest in corpses. In my use of photographs of children, [these] are people of whom I know absolutely nothing, who were subjects and who have become objects, in other words, corpses. . . . These ambiguous relationships are what I find most interesting."[2]

1 From an interview with Boltanski by Delphine Renard, in *Boltanski*, exhibition catalog. Paris: Musée National d'Art Moderne, Centre Georges Pompidou, 1984, pp. 72–73.

2 From "Christian Boltanski, La Revanche de la maladresse," an interview with Boltanski by Alain Fleischer and Didier Semin. *Art Press* (Paris), no. 128 (September 1988), pp. 4–9.

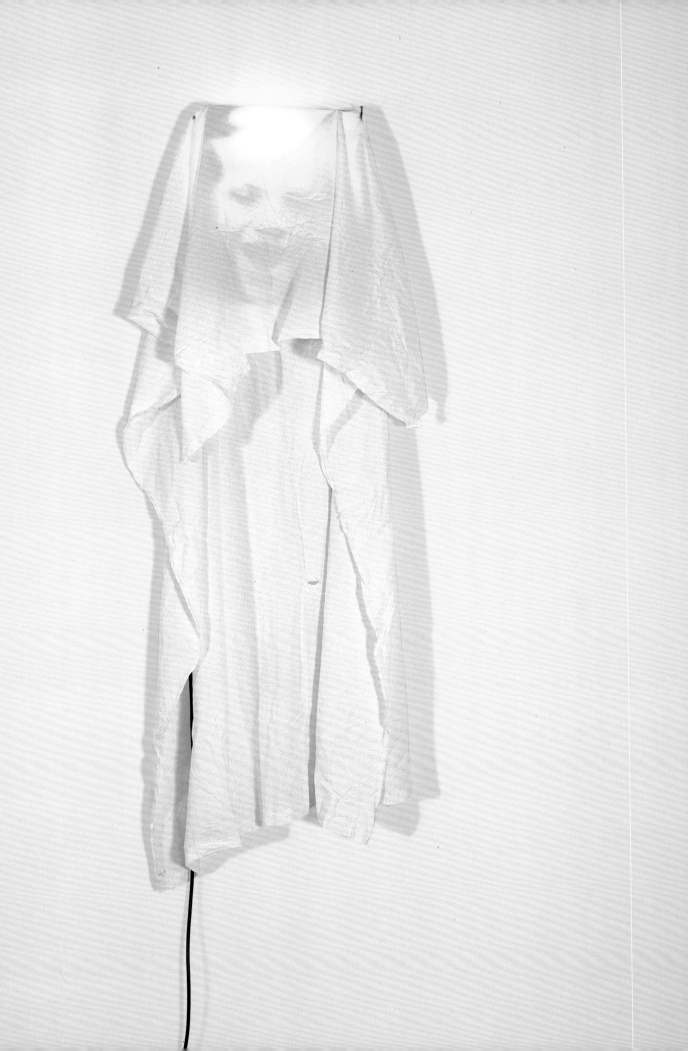

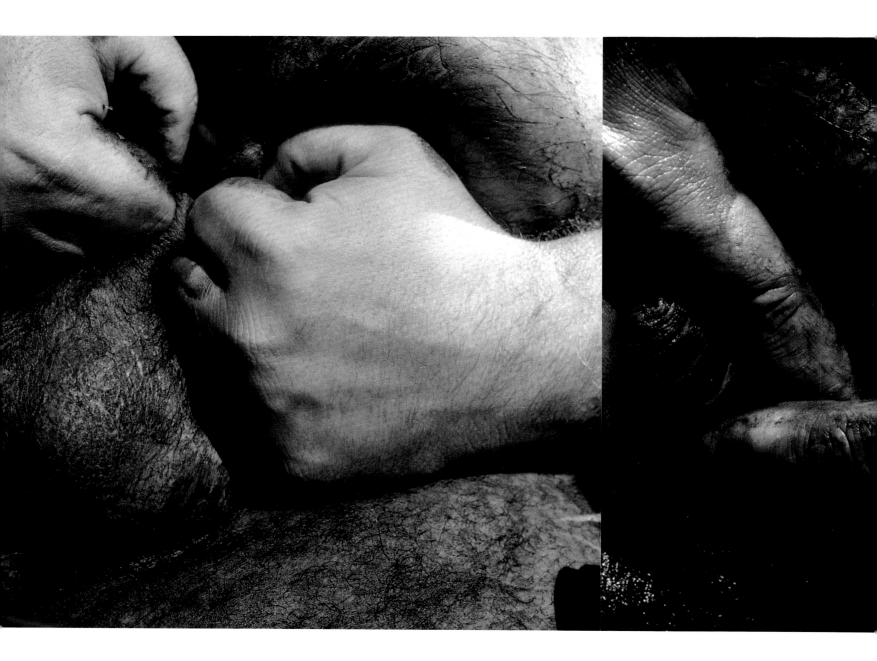

# APARTHEID

PHOTOGRAPHS AND TEXT BY MARC PATAUT

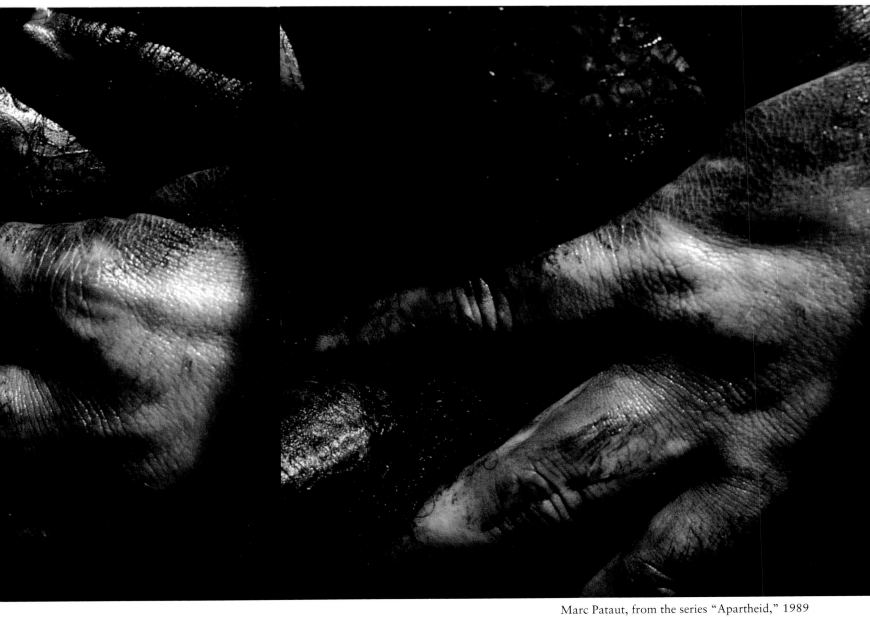

Marc Pataut, from the series "Apartheid," 1989

*To expose our body*
*to set it against ourselves.*
*To translate a feeling of intolerance,*
*to mark it on my own body,*
*white black to the sun.*
*To inscribe there the suffering of others,*
*black, color*
*pain.*

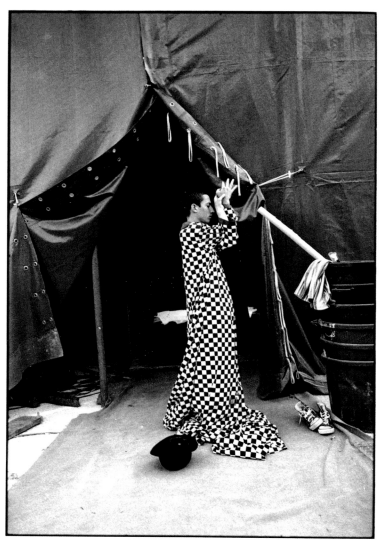

Lise Sarfati, Theater festival, Avignon, 1995

# THE THEATRICAL IDENTITY

PHOTOGRAPHS BY LISE SARFATI,
PIERRE ET GILLES,
JEAN-FRANÇOIS LEPAGE,
KEIICHI TAHARA

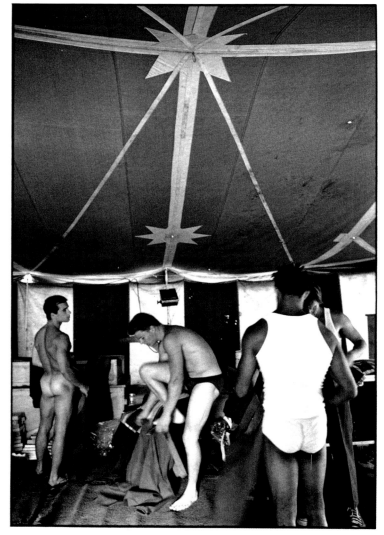

Lise Sarfati, Theater festival,
Avignon, France, 1995

In his poem "Phantom of the Clouds," Guillaume Apollinaire describes the performance of a troupe of traveling acrobats:

> *The little saltimbanque turned a cart-wheel*
> *With so much harmony*
> *That the organ stopped playing*
> *And the organist hid his face in his hands.*
>
> *The angelic music of trees*
> *The disappearance of the child*

This is a spectacle that seems to stop the motion of the world; it cannot be ignored. There is an allure to it, a physical self-consciousness, a glamour, a sense of decadence and of ineluctable loss. Can we dismiss our own role in these spectacles?

The poem ends:

> *But each spectator looked in himself for the miraculous child*
> *Century O Century of clouds*

The photographers in these pages invite us to their performance; they implicate us—we cannot get away from them; they demand that we look in ourselves for the miraculous.

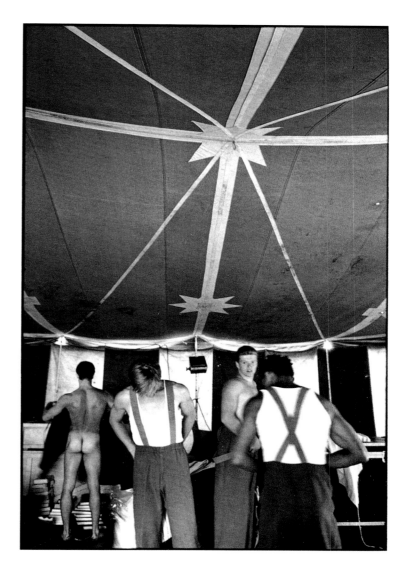

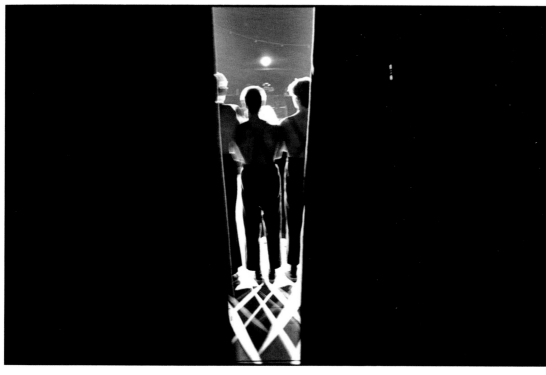

*Above*: Lise Sarfati, Theater festival, Avignon, 1995

*Left*: Lise Sarfati, Theater festival, Avignon, 1995

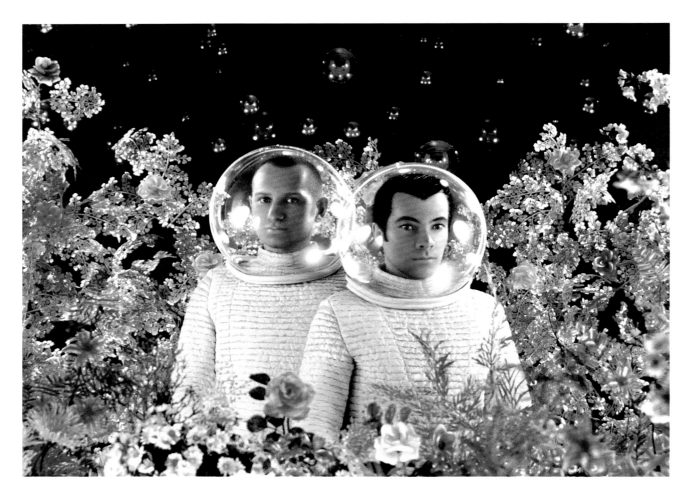

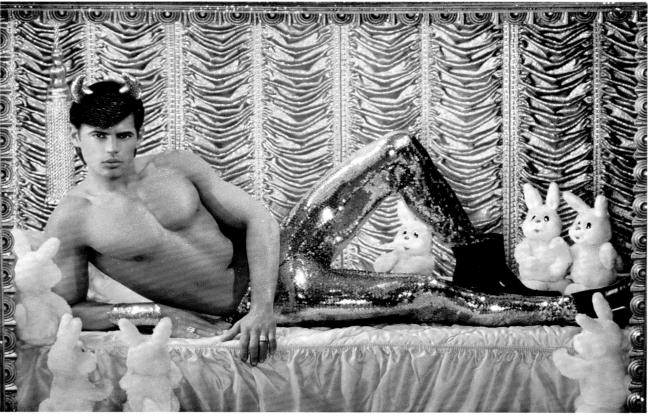

*Above*:
Pierre et Gilles,
*Les cosmonautes
(Pierre et
Gilles)*, 1991
*Below*:
Pierre et Gilles,
*Jeff (Jeff Stryker)*,
1991

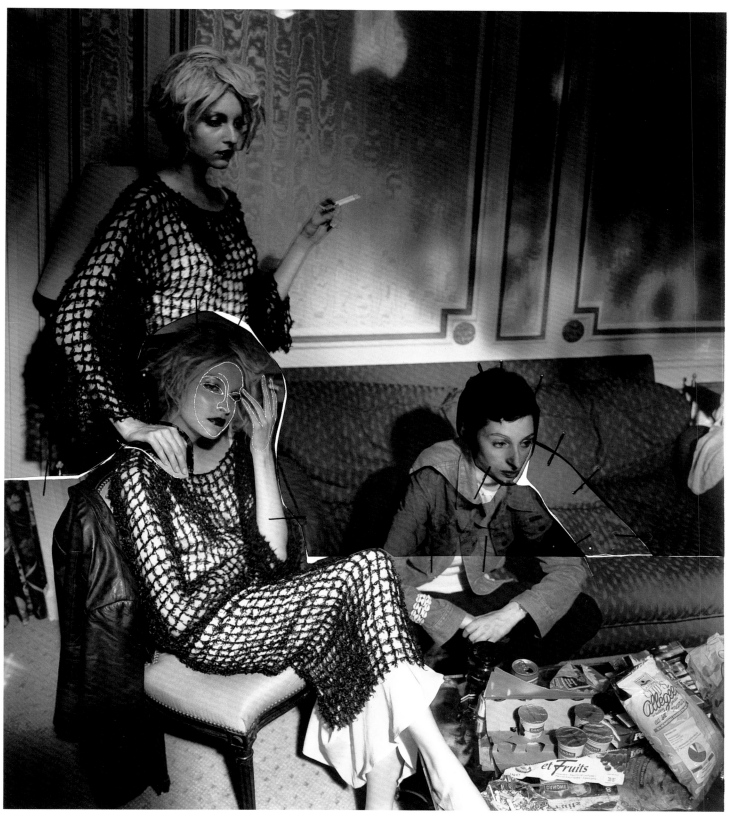

Jean-François Lepage, *Recherche personnelle* (Personal research), 1994

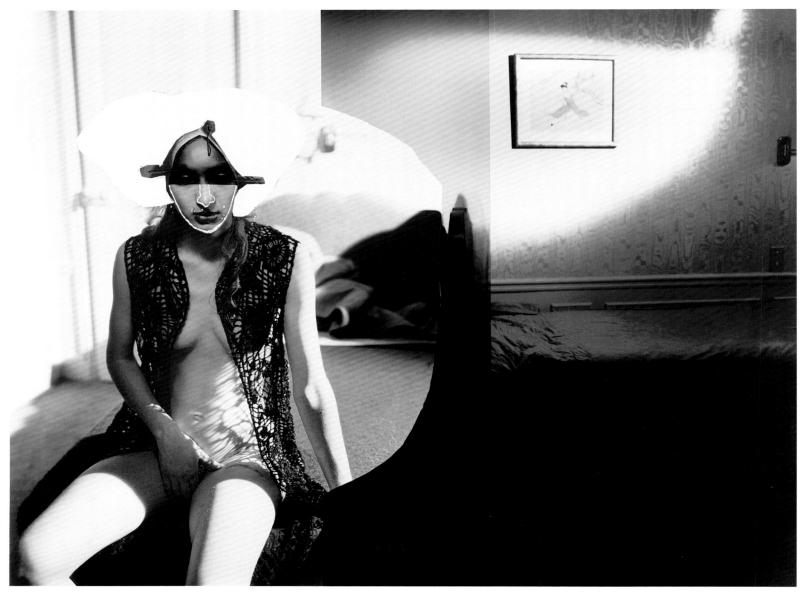

Jean-François Lepage, *Recherche personnelle* (Personal research), 1994

## Sines
By Raymond Queneau

*When One made love to Zero*
*spheres embraced their arches*
*and prime numbers caught their breath*
*holding out their hands to fresh larches*
*simple fractions fractured to death*
*lay down in the torrent of silent decimals*

*When B made love to A*
*the paragraphs caught fire*
*the commas caught their breath*
*holding their necks over a bridge's arc*
*and the alphabet fractured to death*
*vanished into the arms of a silent question-mark*

Translated from the French by Teo Savory.

Keiichi Tahara, *Nu* (Nude), 1985

Keiichi Tahara, *Nu* (Nude), 1985

# PHOTOGRAPHY IN ITS CHILDHOOD

## AN INTERVIEW WITH ROBERT DELPIRE

*Robert Delpire, the director of Paris's Centre National de la Photographie, has for many years been one of the central figures in the field of photography in France. During the course of his career, he has divided his time between his roles as publisher, creative director, film producer, and international exhibition organizer. In this interview, he discusses the ethics and endurance of photography in a rapidly changing world.*

**Aperture:** Did you have an overriding vision for photography from the start? How has that vision changed?

**Robert Delpire:** I am not sure I understand the question. You said, "from the start." Which start? From the invention of photography? Whatever the meaning, no, I do not have an overriding vision of what it should be. I believe that art is eminently changeable, that it evolves according to a multitude of influences, trends, fashions, and—in the case of photography and cinema—to technology.

In 1982, when we discussed with Jack Lang the concept of the Centre National de la Photographie [CNP], we immediately agreed that the Centre should support all forms of photography, without privileging any particular aspect. For him as well as for me, photography is *pluralistic*. The CNP therefore has an ecumenical vocation. I strongly believe that this is true, that sectarianism is wrong, especially in the case of an institution that offers itself to a wide public.

**Aperture:** With the rapid changes and developments in media over the past years—first television, then digitization, the global "internet," and so on—how do you see the role of photography changing?

**R. D.:** At only 150 years old, photography is still in its childhood. And—although photographers began very quickly to exploit the medium, with an often surprising confidence in their own judgment and in the variety of modes of expression—photography will never cease to change. Not only because of technology, but also because of the author's sense of purpose.

The divide between reportage and conceptual photography is absurd. Robert Frank showing passengers in a bus in New Orleans says as much about himself as Joel-Peter Witkin does accumulating severed heads. The good "reporters" do not report on what they see but what they think about what they see.

How do I see the role of photography changing? Keep changing.

**Aperture:** Is this affecting the role of the museum?

**R. D.:** As far as photography is concerned, the museum has finally acquired a status it should have acquired a long time ago. The museum curators have discovered, a little late, the richness of photography, the diversity with which it can not only satisfy the more scientific among us, but also appeal to the more sensitive. So they exhibit, with more funds and more space than the private institutions, their own collections or those belonging to others. And obviously this action is beneficial to the reputation and promotion of the medium.

**Aperture:** How did you orginally become involved with photography?

**R. D.:** When I was a kid, they had these strange machines in the Parisian cafés—a kind of crane which you manipulated to try and seize an object in its claws (a pen, a toy car, a bag of sweets). You never caught anything. Then one day I got lucky and caught a small, black Bakelite camera, with which I took a picture of my cat. My interest in photography dates back to that memorable day.

But don't ask me why, at age twenty-three and with no money, I published a magazine called *Neuf*, which featured Cartier-Bresson and Brassaï and Doisneau and Frank (it was five years before . . . *The Americans*).

**Aperture:** It seems that in the near future such photography-oriented magazines as *Life* and *Paris Match* may be obsolete. Does this mean a cataclysm for photography or are there new roles for the medium?

**R. D.:** Television has not killed cinema. And it won't kill photography. The very synthetic quality of a good photograph, its meaning, even its immutability, radically differentiate it from televized narrative. The two media complement each other.

Aperture: Is there an ethic for photography? Is photography more useful as a social tool or as an aesthetic one?

R. D.: All means of expression imply an ethic. Photography as well as other art forms. And the use that a photographer makes of reality forces him to be perfectly lucid about what he shows and what he says. Reality is so diverse—death, war, famine, social inequality—that one must possess a perfect awareness of how it is used by the media. The utter confusion of the Gulf War, Bosnia, Chechnya, Rwanda, oblige the photographer, although worthy of this title, to forfeit his values.

Aperture: Is there a particular work or body of work that at some point changed the way you thought about the medium or changed the way you see generally?

R. D.: No.

Aperture: How important is the museum context for photography?

R. D.: Ask Richard Avedon. He is convinced that the museum is a place deserving supreme recognition, to the extent that the Palais de Tokyo was unworthy of his work. Despite my insistence and the various proposals I made to him, he would only agree to exhibit his work in Paris if it was at the Grand Palais or the Pompidou Centre, alongside Bacon or Brancusi. It's a point of view that I despise—but yet I respect. And Avedon is not alone in his conviction. But in France it is the so-called conceptual (for want of a better word) photographers who are reticent.

It seems to me that the public is indifferent to this kind of attitude and appreciates Brassaï, whether at the CNP or the Museé Carnavalet, and pays tribute to Cartier-Bresson wherever he may be presented, as long as it is done well.

Aperture: Both as a curator and as a publisher of photography

Photograph of Robert Delphire by Sarah Moon, 1995

books, how do you approach the juxtaposition and sequencing of images? Is there a conceptual difference between publishing and exhibiting photography?

R. D.: In principle, there isn't a difference. Publishing and exhibiting require the same respect for the work and its author, the same concern to reveal the true specificity of the artist. A book or an exhibition succeeds when the organization of the works increases the interest in each individual one.

But I have learned from experience that one cannot copy a book to make an exhibition. And vice versa. The positioning is different and a frontal vision, where the eye absorbs several images at a time, modifies the perception.

Aperture: Do you have a hero?

R. D.: No, I don't have any heroes. And I never have, not even when I was a kid. Just a "coup de coeur" for Marilyn Monroe, like everyone else.

However, it is talent that dazzles me. No matter which kind, no matter where it comes from. The talent of a mason at the turn of the century building a farm. But also those we can name: Kathleen Ferrier singing Mahler. Bonnard painting flowers. Josef Koudelka looking at the sea. Claude Roy writing about death, etc. . . . Yes, it is talent that dazzles me. I am what Jean Genet called an "admiromaniac."

Aperture: Do you have a "dream project"—a publication or an exhibition that you have always hoped to do?

R. D.: My dream is that of all publishers: I discover, by chance, a series of photographs of exceptional quality whose author is unknown. The book is a success. The author becomes famous. And he becomes my friend. I know how that feels. This dream, I dreamt it (almost).

# PEOPLE AND IDEAS

## WORKING AT THE HUMAN LEVEL

Interview with Marcel Ophüls
by Jean-Michel Frodon

*Filmmaker Marcel Ophüls, director of such landmark documentaries as* The Sorrow and the Pity *(1971) and* A Sense of Loss *(1972), has recently brought us* Veillées d'armes *(translated as* The Troubles We've Seen: A History of Journalism in Wartime*). Here, Ophüls speaks of some of the political, artistic, and ethical challenges he encountered in the creation of this extraordinary film.*

**Jean-Michel Frodon:** How did you make *Veillées d'armes*?

**Marcel Ophüls:** Like all my previous documentaries: they are "postscripted" films. I never use voice-over narration. I detest films that are illustrated editorials.

I have never considered that the correctness of a cause meant that all methods were allowed. It is not just by chance that John Huston, George Stevens, and William Wyler made the best documentaries about World War II, and that subsequently, Eisenhower wanted nothing to do with them! Why? Because they have a personal point of view and an understanding of dramatic structure: they are *filmmakers.*

On the other hand, when the dominant culture or the dominant counterculture uses images in a collective spirit, they result—regardless of the individual convictions of the directors—in collectivist films. They result in propaganda, rather than films "at the human level."

My method of working consists of filming as much as possible—for *Veillées d'armes* I had about one hundred and twenty-five hours of rushes. Next, I go off to write the script based on that material. This is where the real work begins, the search to find how a certain smile fits with a certain gesture, to unite what goes together and makes sense, what tells a story and expresses an idea, or ideas. I deplore those who use documentaries to avoid ideas.

**J-M. F.:** Among those ideas is the parallel between the current situation in Bosnia and the situation prior to World War II.

**M. O.:** The comparison is inevitable, but it reaches a limit. The major difference between Sarajevo and Madrid—besieged as it was by Franco supporters—is that the Serbs have no equivalent to Hitler or

Mussolini backing them. It is not so much a tidal wave of fascism as a tidal wave of cynicism that must be stopped today. Which leads to another difference: the noninterventionists of the past had reasons to fear Hitler, whereas this time around, we are retreating before an army of mean and brutal soldiers, of drunks and rapists whose commanders are second-rate bluffers. If we do make this comparison, then it is to the discredit of today's cowards. I spent three months in the company of Daladier when I was making *Munich ou la paix pour cent ans* [Munich or one hundred years of peace]; he showed lucidity and humility with regard to what he had done. I have sought in vain an equivalent to his attitude in the arrogance of our current leaders. . . .

If we find the necessary wherewithal, this will be the subject of a third film: the betrayal of politicians and the way in which they orchestrated a media lie to prevent the public from becoming alarmed. Their only excuse is that there are no volunteers in Europe today willing to go fight in Sarajevo. If we are supposed to believe that we need the Comintern in order for international brigades to exist, then the human condition is truly rotten.

**J-M. F.:** At the beginning of your film, Philippe Noiret points out that after World War II, it was said that if people could have seen what was happening, they would have stopped the horrors. Yet today we see what is happening, but nothing has changed. On the other hand, some believe that, rather than revealing reality, images help to mask it.

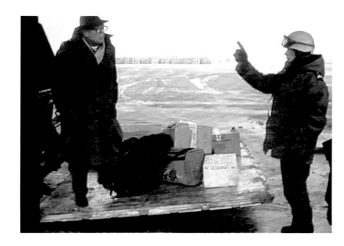

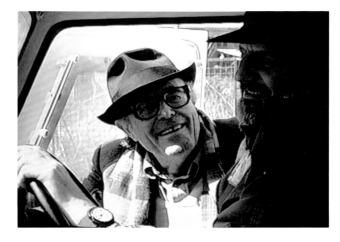

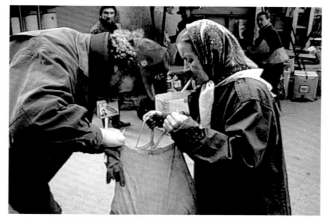

Pages 70–71: Film stills from Marcel Ophüls, *Veillées d'armes: Le Journalism en Temps de Guerre* (The Troubles We've Seen: A History of Wartime Journalism), 1994, 35mm, color, 233 minutes.

**M. O.:** I went to Sarajevo without preconceived notions, and I was captivated by those journalists who take genuine risks to try to inform and raise public awareness. One of them, John Burns, says that contrary to what normally occurs in large hotels that become a base for the international press during conflicts, there are *no* debates at the Holiday Inn in Sarajevo. Everyone knows who the aggressor is, who the bastards are. So, unlike what Romain Goupil says in my film, it seems to me that journalists are doing their job. But they are trapped: they are prisoners and they know it. Stephane Manier says that when he returns to Paris and is complimented for his "excellent subject," he feels ashamed.

When editors in Paris, London, or New York demand human flesh for their human interest stories and journalists must find and deliver three minutes' footage of a blinded child, it is unbearable.

It is the manner in which these images are used and the behavior of television stations at all levels that create the problem. In *Veillées d'armes*, I accuse Canal Plus (incidentally, a coproducer of the film) of showing murderous irresponsibility by sending twenty-three people without any protection to make one episode of the program *24 Heures*. . . . At the same time, the control of images today is frightening. I have to pay astronomical fees when I use film excerpts. When I show how television news summaries are put together, where it is deemed better to begin with Prost's triumph than the bombing of Sarajevo, I am attacked by FOCA (the organization that markets Formula One) for showing an image of the racer that everyone had seen.

The film talks about these obstacles and distortions; however, I reject the relativistic way of thinking that maintains that to show images or not to show them amounts to the same thing. When there are no cameras, it's total barbarism. . . . When one is a documentary filmmaker, one does not have the right to be relativistic. There is only one reality: either collective rapes are occurring or they are not—reality is not somewhere between the two. If they are occurring, then the story must be told and they must be shown, even practically. It is like the fable of the twelve blind men who come across an elephant: each one taps a part of the animal with his cane and together they conclude—it's an elephant. Because they share information. When one begins to doubt the possibility of capturing the truth, much less whether it even exists, one quickly reaches a point where "it's all the same"—that is, cynicism, the worst possible point.

*Translated from the French by Karin Lundell.*

*This interview originally appeared in the May 17, 1995 issue of* Le Monde, *and is reprinted with permission of the publisher.*

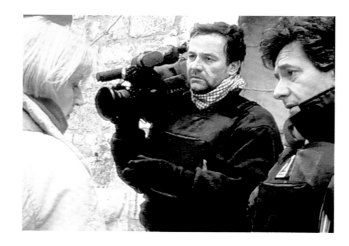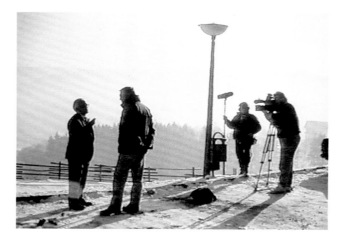

# SEÑOR PABLO'S UNSEEN PHOTOGRAPHS

## by Joan Fontcuberta

Picasso's contribution to photography has hardly been studied. The exhibition "Picasso Photographe (1901–1916),"[1] presented at the Musée Picasso in Paris in June 1994, threw some light on this aspect of the artist's work. Picasso was shown to have been a prolific amateur photographer who documented his own studio and the still lifes there that he used as models, but he also made some self-portraits and landscape pictures. The images selected for this showing brought out interesting facts regarding his way of working but did not reveal a desire for specific expression.

It was probably later, through his friendship with Brassaï and his close relationship with Dora Maar, that Picasso began to consider photography more seriously as a creative medium. There is no doubt that his most complete photography project was the series of lithographs titled "Diurnes" (1962), carried out in collaboration with the French photographer André Villiers.[2] Villiers and Picasso had known each other for some time. Fascinated by the landscape of Provence, where they both lived, they decided to collaborate on a project based on applying *découpages* with Picasso's typical silhouettes of animals and mythological figures over landscapes and natural elements photographed by Villiers. Thus it was a matter of combining photograms with conventional photographic prints.

Photographer and painter shut themselves up for fifteen days in the darkroom that Villiers had rented in Lou Blauduc, a magnificent country house located between Mas Thibert and Salin-de-Giraud, in the middle of the Camargue. The herds of horses or fighting bulls that grazed freely on the surrounding land probably inspired many of the compositions. Professor Rosalynd Kroll was absolutely correct when she wrote, "'Diurnes,' in short, possesses all the experimental force of the incursions of the surrealists and at the same time the poetic charge of the Mediterranean sensibility, the exaltation

of the sources of its aesthetic memory, the magic of its most visionary origins. It is like the encounter of a shepherd and a siren on top of the trunk of a Buick considered as a ready-made."[3]

While in Lou Blauduc the two artists produced over fifty originals, from which they selected some thirty for the edition of lithographs. Obviously, nothing more was known of the rejected proofs. It was a great surprise when Jean-Pierre d'Alcyr, art critic of *La Depêche du Midi* and professor at the University of Aix-en-Provence, recovered the forgotten images. After receiving permission from the present owners of Lou Blauduc to search the attic, d'Alcyr found various laboratory utensils, two envelopes of Agfa photographic paper and a third envelope of Mimosa photographic paper. These envelopes contained the proofs that were never used. Many prints were splotched or improperly fixed; others are slightly different versions of those finally chosen. But as a whole they permit one to analyze "Diurnes" from another perspective: one that shows not only the finished results but also the entire process of the work, the successive phases of selection, the doubts of the two artists, their final compromise.

This material has been shown in public only once. Through my personal friendship with d'Alcyr I succeeded in borrowing twenty of these unpublished originals with the intention of exhibiting them in the Museu Picasso in Barcelona between March and June of 1995. That exhibition formed part of a cycle, curated by me, titled "The Artist and the Photograph," which also included photographic works by two other great Barcelona artists: Joan Miró, in an exhibit at the Miró Foundation in Barcelona, and Antoni Tàpies, also in his Barcelona foundation.[4]

1 Baldessari, Anne: *Picasso photographe, 1901–1916*. Paris: Musée National Picasso, 1994.

2 See Porras, Maria Lluïsa: *Duets fantàstics: Picasso-Villiers & Picabia-Cravan*. Barcelona: Fundació la Faixa, 1990.

3 Kroll, Rosalynd: *Light and Shade in Surrealism*. Booneville, MS: Northeast Saint-Thomas University Press, 1989.

4 See Hanhardt, John G. and Keenan, Thomas: *Els límits del museu*, Barcelona: Fundació Antoni Tàpies, 1995.

*Translated from the Spanish by Cola Franzen.*

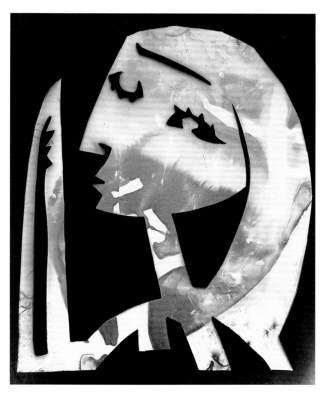

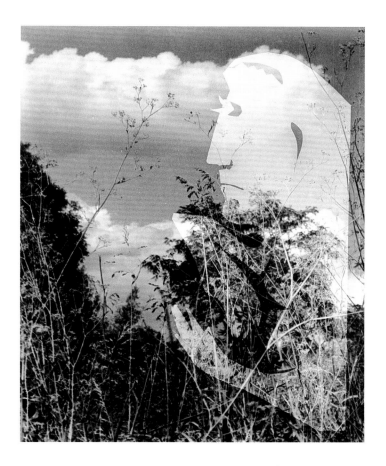

*Pages 72–73*: Selected images from the "Diurnes" portfolio

---

## INTERVIEW WITH JEAN-PIERRE D'ALCYR

**Joan Fontcuberta:** How did you happen to find this extremely important unpublished material?

**Jean-Pierre d'Alcyr:** By pure chance. In a course I gave at the University during the second semester of 1993 I mentioned the work of Picasso and the influence that our region, its landscape and light, had on it. A student then said that as a matter of fact Picasso had worked in Lou Blauduc, one of the properties owned by his parents.

**J. F.:** Did the parents of that student know of the existence of those pictures?

**J-P. d'A.:** No, and if they had known they would have attached no importance to them. They had only the vague memory of a hearty roguish individual—quite a character!—whom neighbors affectionately called "Señor Pablo." His wife, Jacqueline, also made a strong impression. . . .

**J. F.:** Since they had just moved into the new house of Nôtre-Dame-de-Vie in Mougins, with terrific space for working, why did they go quite far away for that collaboration with Villiers?

**J-P. d'A.:** Well, just for that reason. The house was new and Jacqueline was afraid that with the fluids of the laboratory everything would be ruined. In order to talk Pablo into moving they told him he would be near Arles and would be able to go to the bullfights. The bullfighting season in the Arles Arènes has always attracted the aficionados. For Villiers also it was more comfortable not to have to move the laboratory to another site.

**J. F.:** What is the status of these works now?

**J-P. d'A.:** Let me emphasize that in the first place these are not "works" properly speaking. They are proofs of work that were discarded. For whatever reasons, they did not pass the self-criticism of their creators. In some cases one can see obvious technical defects, but in others I imagine it must have been due to aesthetic criteria.

**J. F.:** Who owns the works now or where will they end up?

**J-P. d'A.:** The ownership is a controversial subject which I cannot address. When things are clarified, if the pieces go on the market, probably the French government will exercise its right. Monsieur Pierre Bonhomme, general director of the Mission du Patrimoine Photographique, is keeping very close track of the situation. In any case, they are pictures that have not been signed, that were rejected, that could have gone into the trash; they have only a scholarly interest, didactic, if you will, for critics and historians. The logical outcome would be that the collection not be broken up and would be housed in some museum.

*Translated from the Spanish by Cola Franzen.*

# REREADING THE PAST

Interview with Pierre Bonhomme
by Gabriel Bauret

*Pierre Bonhomme is the director of Paris's Mission du Patrimoine Photographique. Gabriel Bauret questions Bonhomme about the prestigious archive's role, and the importance of the old in the creation of the new.*

**Gabriel Bauret:** As director of the Mission du Patrimoine Photographique, how would you describe current interest in the history of photography?

**Pierre Bonhomme:** I should begin by explaining that the Mission du Patrimoine Photographique is part of the National Heritage Division of the French Ministry of Culture. It is responsible for conserving, managing, and making available to the public photographic holdings belonging to the French State. Our holdings cover the entire history of photography. We receive many requests for documentary work, and specific subjects—for example, Paris at the beginning of the century, or the portrait of a particular famous person. Other requests may relate to the illustration of a more abstract, timeless concept, or to the representation of an idea or a state of mind.

**G. B.:** So in your view, today's interest in the past is very diverse?

**P. B.:** Yes. For example, when William Ewing prepares an exhibit on the human body, he is as interested in a Lartigue photograph taken in a stadium at the beginning of the century as he is in what René-Jacques did thirty years later to illustrate *Les Olympiques* by Henri Montherlant—his idea is to depict athletic challenge and effort. Calvin Klein, on the other hand, is looking for a photograph that reflects a sense of well-being and the joyful freedom of movement.

**G. B.:** Is the fact that advertising agencies and image companies are turning to old photographs a new phenomenon?

**P. B.:** Since the Mission has been in existence, we've had more and more requests from that sector. Also, our holdings have grown considerably richer—and maybe because of this, we are more likely to meet the needs of advertisers who come to us today. They may even make discoveries in our collections. Requests are also increasing because illustrators working in publishing, advertising, and the press today know more about old photography than in the past, thanks to books and exhibitions.

**G. B.:** What was the Mission's original purpose? Was it purely artistic?

**P. B.:** Old photographs cannot be viewed solely as works of art: many of those photographers were responding to needs for documentation and information. A lot of photographs are clearly documentary in nature—look at Nadar and Atget. Nadar is a great artist, but he is also the one, more than any other photographer, who enabled us to *see* Delacroix, Manet, and Baudelaire.

**G. B.:** When you study a proposed donation, do you first consider how that collection might be used?

**P. B.:** Yes, but that is not our only criterion. For example, when we received Bruno Réquillart's collection, we knew it included photographs that would not be as easy to distribute as, for example, the collection of Roger Corbeau's portraits of actors. Réquillart photographed the grounds of Versailles, but he was also involved in much more personal research that is of interest today, especially to photography critics and historians.

**G. B.:** The Mission's role in terms of public service is to conserve works that have a wide range of applications.

**P. B.:** The value of the images that we conserve varies enormously from one photograph to the next. It depends, of course, on how famous the photographer was. Lartigue and Kertész are very popular. Lartigue's work contains so many possible topics: sports, athletics, cars, fashion, women. For Kertész, it's Paris, New York, artists during the period between the two world wars. . . .

There are also many requests for Harcourt studio work (portraits of artists, writers, painters. . .). Denise Colomb's portraits of artists are also very popular, especially whenever a retrospective of Nicolas de Staël, Max Ernst, or Giacometti is organized.

**G. B.:** Do you also organize exhibitions of the Mission's holdings?

**P. B.:** Yes. Exhibitions are first presented at the Hôtel de Sully and then taken abroad, where they can further the knowledge of France's cultural heritage for a larger public.

**G. B.:** Has the way in which works are presented changed?

**P. B.:** It is important to point out that, unlike other institutions such as the Bibliothèque Nationale, the Musée d'Orsay, or the Musée National d'Art Moderne, our collections are not primarily made up of prints. The donations we receive generally consist of the photographer's *negatives*, along with reproduction rights. Most often, what the photographer gives us represents the totality of his or her work. However, before giving it to us, the photographer generally removes what he or she feels is inferior in quality or should not be part of the collection—for personal, political, or other reasons. To give a collection of this kind to the State means that it will be open for consultation by the general public, and that our knowledge of it will evolve. Just as historical circumstances, interests, and tastes differ with each period, so does the approach to subject matter and research. At a given point in his or her career, a photographer might have worked on a very personal subject. Fifty years later, that work may be of interest to a large public. Atget and Lartigue were not immediate successes. Lartigue was unknown before the 1960s, though he began his work in photography at the beginning of the century. We had to wait several decades before discovering his work.

**G. B.:** You speak about the totality of a photographer's work. But within that oeuvre, certain aspects sometimes remain in the dark and largely unexhibited.

**P. B.:** One example is Kertész's color photography. It is interesting to note that he did not use color only on occasion: beginning in the 1950s, he used it continually. Of 100,000 negatives, about 15,000 are in color—which amounts to 15 percent of his work! But in his lifetime, the problems of preserving color were such that this particular aspect of his work was undervalued, and hardly ever exhibited. Kertész found his place in an art market which, in his day, was for the most part black and white. Why should we now show this aspect of his work? Because his work in color is very beautiful and just as sensitive and pure as black and white, and furthermore, because it is an integral part of his life's work. I think that Kertész believed this work might be of interest from a historical point of view and in relation to his work as a whole. The Mission's duty is to make this legacy known. History will be the ultimate judge: it might reject the color photographs, but if it does it will be with full knowledge of them!

**G. B.:** There is a current idea that only those photographs printed during the author's lifetime are recognized to be of value. But do you think that the way in which a work is perceived changes, and that therefore it is important to distance oneself from this notion?

**P. B.:** We know that when Kertész worked for the French press in the late 1920s and in the 1930s, the people who published his work did so according to their own criteria. Kertész did not necessarily consider those publications his best work. Certain shots may not have been shown simply because the magazine article was only four or six pages long. How many photographers have told us that they would not have made the same choices as their editors? As soon as a work becomes public, I think we have the right to examine it and consider all of its components. Many collections (such as those of Cameron, Atget, Coburn, Drtikol, Arbus . . .) go beyond the photographs published and shown during the lifetime of their authors.

André Kertész, *New York*, ca. 1965

**G. B.:** It is interesting to see the shots that were taken before or after the one that is usually considered to be a masterpiece. It helps sometimes to understand what makes the masterpiece so perfect.

**P. B.:** Yes—as in the Martinique variations by Kertész. Also, remember that, among the photographs published during his lifetime, many appeared in magazines with different croppings. Kertész was in the habit of cropping his photographs.

**G. B.:** How do contemporary photographers view this historical legacy?

**P. B.:** Today, there are fewer and fewer completely self-taught photographers. They benefit, of course, from literary and artistic culture, but even more from the vast culture of photography, and inevitably, this culture nourishes their creative work, whether they are conscious of it or not.

Technically speaking, many current photographers are making use of old processes and equipment; and references to the past may also influence some photographers' choice of subject matter or the way in which they treat it. This is really the first generation that has access to such a rich history of photography.

The response can be very direct: Bruno Réquillart went very deliberately to Versailles and photographed there, after seeing Atget's work on the same subject and learning from it.

**G. B.:** So the experience of a past work brings about a new work. Is this the case for many other photographers?

**P. B.:** I think so. Especially for photographers born after World War II. Bruno Réquillart and Daniel Boudinet began their work in photography in the 1970s, at a time when it was becoming much easier to gain access to past works.

**G. B.:** Which works are contemporary photographers more apt to refer to? Are people more drawn to some periods than others?

**P. B.:** It seems to me they are interested in all periods. Portraitists are marked as much by Nadar as by Julia Margaret Cameron or August Sander. The entire history of photography, as it is being rediscovered, provides a frame of reference and a source of information for creative people.

*Translated from the French by Karin Lundell.*

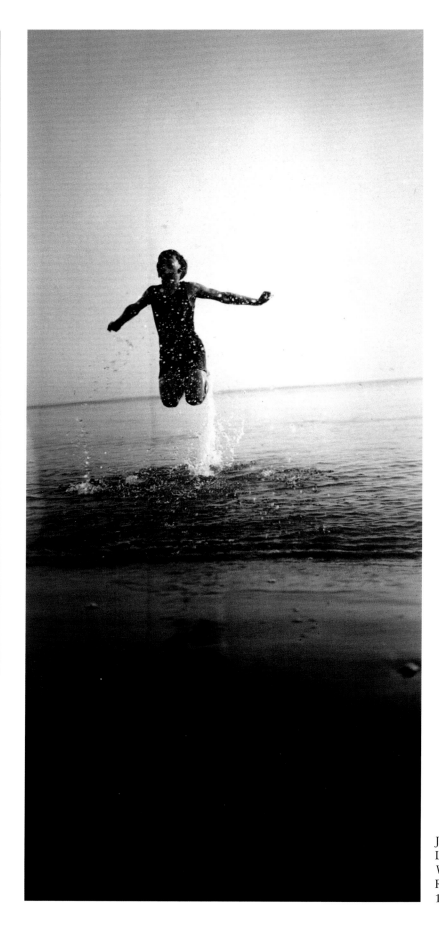

Jacques-Henri Lartigue, *Gérard Willemetz*, Royan, July 1926

# ANNETTE MESSAGER

## Exhibition review by Donald Kuspit

What Annette Messager has achieved is rare: the integration of postmodernism and feminism. Hers is an art of bric-a-brac, in which the sublime and the tacky exist on the same plane. But this may also be a definition of woman: sublime and tacky in one, a disordered bric-a-brac. Messager's self-analysis—these words are hers—and the contemporary analysis of woman converge; in the idealistic words of Hélène Cixous, woman is a "limitlessly changing ensemble," "composed of parts that are whole." But, in emotional reality, these parts do not fit together, and even verge on violent contradiction.

Fragmentation is the condition of postmodern being, even more than of Modern being, which at least imagined its own closure. In postmodernism the luxury of such a conclusion is inconceivable: the ironic, carnival-like openness of fragmentation is the only totality. It may be a liberal opportunity, a democratization and decentering—one fragment is as good and "central" as another—but it also suggests a certain futility of being. There is no way of fixing identity, but that leaves the self at the mercy of the flow of fragments within it and impinging on it from outside. The fragments may clump together, but such temporary gatherings are hardly worthy of the ideas of form and identity, especially in the rigid condition in which they can be found in the usual run—and especially in the better-known examples—of American feminist art.

Messager is also a postmodernist on a technical level: utilizing not only the sublime and the tacky, but the photograph, the drawing, the painting, the found object (and found photograph)—not simply overlapping, but interacting, even interlocking in hybrid works. Each element is at once an object and a signifier—a split personality. In *Lines of the hand,* 1987, Messager draws on a photograph of a hand—variously enlarged and reduced—elevated on a pedestal of words. There is no hierarchy of method here, just as there is no hierarchy of image and idea. Indeed, there is a reversal of the usual priorities: the singular, stark image is raised above the logical, discursive word, which is further de-logicized

by being mindlessly repeated, until what was intially haunting becomes meaningless—the image appropriates all meaning.

Indeed, there is a good deal of compulsive repetition, leveling all sense (if subliminally intelligible) in Messager's works. These are not arbitrary album collections, as she calls them; each is devoted to a theme, and overloaded with obsessively collected materials. Taxidermized birds in *Boarders at Rest,* 1971–72; photographs of *Children with Their Eyes Scratched Out,* also 1971–72; three-dimensional hand-fabricated body parts galore in *Penetration,* 1993–94; photographs of other part objects, as the psychoanalysts call them, in *My Works,* 1987 and *My Vows,* 1989; doll parts (onto which woman displaces her identity and narcissistic idealism), as well as drawings of maps, the sites of the atrocities perpetrated against women shown in other drawings, in *The Pikes,* 1991–93.

To me the violence of these images and objects—they are supposed to be a revolutionary call to arms, but they seem like guillotined heads on show—are of less consequence than their redundancy, their sinister abundance. It is a signal of how bogged down woman is in her monstrousness, for which, it seems, violence may be a punishment. Messager's humor does not mitigate it, but refine it. Her *Chimeras,* 1982–83, may be whimsical toys—kites manqué floating on a sky-wall—but they remain threatening, fearsome, female monsters, breathing fire: dragonlike. (However much Messager mocks the notion of the dragon-woman—the woman of authority and power [the phallic woman]—she also glories in it.)

In *Voluntary Tortures,* 1972, she shows photographs of women who have masochistically terrorized their bodies to make themselves mythically beautiful, but who have in fact turned themselves into monsters. What are they satisfying: an insane male fantasy, or their own insane, utopian narcissism? Is the lack of self-certainty, self recognition, their self-punishment—a result of social pressure or of the immaturity that makes them peculiarly monstrous? Woman is a lost monstrous cause, Messager postu-

Annette Messager, *Mes Trophées* (My trophies), 1987

lates, a grotesque creature who disintegrates herself in the process of idolizing herself—who sacrifices herself to a monstrous fantasy of ideal being.

Can one say that the photograph is inherently tragic, that, in stopping time and creating memory, it acknowledges death and makes a cliché of consciousness? It signals loss as much as immediacy, absence as much as presence. The nostalgia to which it is conducive implies as much. Indeed, Messager works with clichéd images and objects, which is why I suggest that the photograph, with its powers of petrification and over-objectification, is implicitly the model of her works. Their basis is the photograph, and many of her drawings copy photographs. This is not only because of the convenience of the photograph as the dominant mode of image in our world, and because it communicates instantly, but because it instantly turns what is present into part of the past. Woman is past, which is past of her monstrousness, Messager seems to be saying. She exists only in the illusion of photographic immediacy. Her existence has been documented in numerous albums of pictures, all of which are full of nostalgia for her, whether as victim or idol. But Messager doesn't know what to replace her with, and despite herself wants her to be irreplaceable.

*A major traveling exhibition of the work of Annette Messager will be presented at the Art Institute of Chicago from February 17 to May 5, 1996.*

# CONTRIBUTORS

JEAN BAUDRILLARD is a prominent voice internationally in cultural and social criticism. His most recent book is *Simulations and Simulacra*. An exhibition of Baudrillard's photographs was shown recently in Paris.

GABRIEL BAURET, formerly editor in chief of *Camera International* magazine, currently works free-lance as a photography editor and curator. He is a regular contributor to numerous publications, and teaches history of photography at the Université de Paris.

NADIA BENCHALLAL's photographs have been widely published in the European press, and have been exhibited around the world. Benchallal was the 1994 winner of the Perpignan Visa d'Or (magazine category), and joined the Contact Press Images agency in 1994.

CHRISTIAN BOLTANSKI was born in Paris in 1944. He is a major figure in contemporary art, has had many solo exhibitions at museums and galleries throughout the world, and has published numerous artist's books.

SOPHIE CALLE has had many solo exhibitions worldwide, and her work has been featured in such publications as *ARTnews*, *Parkett*, *Artforum*, and *The New Yorker*. Along with her installations, photographs, and conceptual projects, Calle has created several artist's books.

JEAN-CLAUDE COUTAUSSE began taking photographs as a reporter for the armed forces. His work in the Persian Gulf, Haiti, Yugoslavia, and elsewhere has been published internationally. The winner of several photography awards, Coutausse has been a member of Contact Press Images agency since 1990.

Photographer/filmmaker RAYMOND DEPARDON was born in Villefranche-sur-Saône. A cofounder of the photography agency Gamma, he received the Capa Gold Medal in 1973. Depardon has made numerous award-winning films, among them *Numéro Zero* and *Reporters*. He has been a member of the Magnum photo agency since 1978.

XAVIER EMMANUELLI was a founder, in 1971, of the international human-rights organization Médecins Sans Frontières, where he currently holds the title Président d'honneur. He has numerous publications, among them *La Morale et la Médecine*. Dr. Emmanuelli practices medicine at the Nanterre hospital, and holds the title Secrétaire d'État à l'Action humanitaire d'urgence for France.

Writer ANNIE ERNAUX is also a professor of modern literature. Several of her books have been published in the United States, among them *Cleaned Out*, *A Man's Place*, *A Woman's Story*, *A Frozen Woman*, and *Simple Passion*.

BERNARD FAUCON holds a master's degree in philosophy from the Sorbonne. He is the winner of several prestigious awards, including the Grand Prix National and the Prix Léonard de Vinci. His book *Idoles et Sacrifices* was published in 1994. He is represented by Agence Vu.

CAROLINE FEYT's photographs have appeared in *Photographies Magazine*, *Art Press*, *Foto Pratica*, and *Photoblätter*, among other journals, and there have been two books of her work: *Toros* (1990) and *Montagnes et Portraits* (1993). Feyt has received several awards, including the Prix Européen de la Critique Photographique Kodak in 1993.

GLADYS has worked extensively in Japan and in France, and her photographs have appeared in numerous gallery exhibitions in France and abroad. She was the winner of the 1989 Prix Niépce. In 1993, a book of her work, *Album*, was published by Éditions Créaphis.

JEAN-FRANÇOIS JOLY has been a member of the Agence Editing since 1992. His photographs have appeared in such publications as *Libération*, *Le Monde*, *Life*, and *Paris Match*, among many others. His ongoing series on homelessness, "Naufragés de la ville," was exhibited in 1994 at Paris's Mois de la Photo.

MI-HYUN KIM received her master's degree in the semiology of the cinematographic image in 1989 from the Université de Paris, and turned to photography soon thereafter. A member of the Métis agency, Kim has had her work exhibited in a number of museums and galleries in France.

MARC LE MENÉ, a painter and photographer, has had numerous solo exhibitions both in France and abroad. In 1985, he was the first-prize winner of the Centre National de la Photographie's award for photographers under thirty. His work is in numerous collections, including those of the Centre Pompidou and the Maison Européenne de la Photographie.

Photographer and painter JEAN-FRANÇOIS LEPAGE's work has appeared in numerous group and solo shows in France, Poland, the United States, and Japan, including 1994's "Treize en vue" exhibition in Chalon-sur-Sâone.

DOLORÈS MARAT is self-taught as a photographer. She has had numerous solo exhibitions in Europe: at the Galerie Focus, Amsterdam; the Mois de la Photo, and FNAC Etoile, in Paris, among other venues. Her most recent publication is *Rives* (Marval, 1995).

SARAH MOON's fashion images have been widely seen in such publications as *Vogue*, *Harper's Bazaar*, *Marie-Claire*, and *Elle*. Moon has also made numerous films; two of them, *Le casting* and *Loulou*, received the prestigious Lion d'Or award. Her publications include *Souvenirs improbables* (1981) and *Vrais semblants* (1991). She had a major solo show at Paris's Centre National de la Photographie in 1995.

MARIE-PAULE NÈGRE is a photographer and filmmaker, and was a founder of the agency Métis in 1989. She has been working for many years on the theme of the "new poverty" in France. Last year, the Centre National de la Photographie in Paris presented a show of Nègre's photographs, and she was awarded the prestigious Prix Niépce.

MARC PATAUT is a founder of the association Ne Pas Plier, devoted to the creation and distribution of images that address urgent national and international causes. His work has appeared in exhibitions at major institutions throughout Europe. He currently teaches photography at the École Supérieure d'Art et de Design in Amiens.

PIERRE ET GILLES began their collaboration in 1976. Their work has appeared in many exhibitions at museums and galleries throughout the world. In 1993, they were awarded the Grand Prix for Photography by the City of Paris.

LISE SARFATI was born in Oran, Algeria. She received a degree in Russian studies from the Sorbonne, and published her first photographic work in 1986. Sarfati recently won a grant from the French Ministry of Culture for her ongoing study of runaway children in Russia. Last year, she was awarded a Kodak Visa d'Or prize at the Perpignan photography festival. She has been a member of Contact Press Images since 1992.

JEANLOUP SIEFF studied photography in Paris and in Vevey, Switzerland. His early fashion photography appeared in such publications as *Vogue*, *Elle*, *Glamour*, and *Harper's Bazaar*. A monograph of Sieff's work was published by Contrejour in 1990. In 1992, he began his work on the traces of World War I battles, which will be published as "Souvenirs de Guerre."

CHRISTINE SPENGLER began photographing in 1970, in Chad. Since then, she has worked as a war-photographer/correspondent in Northern Ireland, Vietnam, Cambodia, Beirut, El Salvador, Iran, and elsewhere. Spengler's work is in many collections, including the Bibliothèque National, the Musée Nicéphore Niépce, and the Eastman Kodak Museum.

Born in Japan, KEIICHI TAHARA has lived in France since 1972. He has created photographic series on a variety of themes, and has worked with fashion designers such as Yohji Yamamoto and Issey Miyake. In 1988, Tahara was the winner of the prestigious Prix Niépce.

## CREDITS

Unless otherwise noted, all photographs are courtesy of, and copyright by, the artist. Front cover photograph by Marc Le Mené; p. 1 photograph by Bernard Faucon, courtesy Agence Vu/Galerie Yvon Lambert, Paris; p. 18 polaroid transfers by Mi-Hyun Kim, courtesy Agence Métis, Paris; pp. 20–23 photographs by Sophie Calle, courtesy Luhring Augustine Gallery, New York; pp. 24–27 photographs by Bernard Faucon, courtesy Agence Vu/Galerie Yvon Lambert, Paris; p. 32 photographs by Raymond Depardon, courtesy Magnum Photos, New York; pp. 33–35 photographs by Raymond Depardon, courtesy Centre National des Arts Plastiques, Paris; pp. 37–39 photographs by Jean-François Joly, courtesy of Agence Editing, Paris; pp. 40–43 photographs by Marie-Paul Nègre, courtesy Agence Métis, Paris; pp. 44–47 photographs by Nadia Benchallal, courtesy Contact Press Images, Paris; pp. 49–51 photographs by Jean-Claude Coutausse, courtesy Contact Press Images, Paris; pp. 52–55 photographs by Christine Spengler, courtesy Leslie Barany Communications, New York; pp. 56–59 photographs by Christian Boltanski, courtesy Marian Goodman Gallery, New York; pp. 60–61 photographs by Marc Pataut, courtesy Galerie Sylviane De Decker-Heftler, Paris; pp. 62–63 photographs by Lise Sarfati, courtesy Contact Press Images, Paris; pp. 70–71 film stills courtesy of Président Film, Paris; pp. 72–73 The Picassoid photograms in these pages were made by Joan Fontcuberta for an exhibition entitled "The End(s) of the Museum," organized by the Fundació Tàpies in Barcelona, and presented in March 1995. As part of the project, Fontcuberta also created images in the style of Joan Miró and Antoni Tàpies, which were exhibited in their respective Barcelona foundations. Because Fontcuberta's "Picasso" images and surrounding documentation were so convincing, the Museu Picasso in Barcelona refused to present the work in the museum as authentic; pp. 75–76 photographs by André Kertész and Jacques-Henri Lartigue, courtesy of the Association Française pour la Diffusion du Patrimoine Photographique, Paris. TEXT CREDITS: Robert Desnos's "Mi-route," translated as "Midway" by George Quasha, from *Fortunes* by Robert Desnos: Éditions Gallimard 1942; Tristan Tzara's "Soir," translated as "Evening" by Charles Simic and Michael Benedikt, from *Oeuvres complètes*, Flammarion, 1975, 1979; Raymond Queneau's "Cygnes," translated as "Sines" by Teo Savory, from *L'Instant Fatal* by Raymond Queneau: Éditions Gallimard 1948; Blaise Cendrars's "Au Coeur du Monde," translated by Anselm Hollo as "In the World's Heart." Poems reprinted by permission of their translators.

# Create a new camera class, and people start talking.

*"The remarkable Contax G1 35mm camera has re-engineered the staid interchangeable lens rangefinder category."*

-Popular Science
Grand Award

Combine the sophistication of an SLR with the characteristics of a compact camera and *"the result is nothing less than an instant classic, the machine designed to delight camera connoisseurs, whether they be pros, advanced amateurs, or well-heeled dilettantes."* — (Popular Photography); it's the Contax G1. The G1 is a camera system that provides the control and precision you would expect in a Contax SLR, but in a small, versatile package.

*"The 90mm Sonnar is the benchmark of its class - the best medium tele we have yet tested."*

-Popular Photography

The G1 system has four newly designed, interchangeable Carl Zeiss T* lenses, representing the finest lens series ever. They include: The AF Biogon 28mm f2.8, the Planar 45mm f2.0, the Sonnar 90mm f2.8, and the Hologon 16mm f8.0. *"The 45mm f2 and the 90mm f2.8 both exhibit knife-edge sharpness, excellent contrast and color characteristics that the Zeiss name is known for."* — (Photo Pro)

These new lenses provide the highest contrast and resolution, coupled with the lowest distortion possible. Because the G1 doesn't require a mirror box or pentaprism, lens designers had the freedom to work toward higher optical performance. An additional benefit of this design is significantly reduced noise and vibration.

A selection of your current T* SLR lenses can also be used on the G1 with the optional GA-1 Mount Adapter.

*"The camera focused smartly and accurately in all situations, and the mechanics of the camera function with a pleasing smoothness and precision."*

-Petersen's Photographic

The viewfinder of the G1 zooms to match the installed lens and automatically makes parallax and focal distance corrections. The viewfinder includes an adjustable diopter (+.3d to -2D), that when selected, allows easy use without eyeglasses. Compared to conventional compact cameras, the G1 has more accurate focusing because of it's advanced passive auto focus system and extended base length. Of course, the G1 retains a manual focus system to preserve the photographer's ability to choose.

A full complement of accessories will enhance your G1 including filters, lens shades, GD1 Data Back and TLA140 Electronic Flash.

Also available is a brand new, ultra compact G1 system bag. Crafted in full-grain leather, it includes individual compartments for your G1, all four lenses and accessories. The plush, cushioned interior, with innovative fold down front compartment, provides ultimate accessibility and protection. *A must for every G1 owner!*

*"This compact, extremely elegant new camera comes very close to the kind of picture taking machine I would have designed myself."*

-Photo Pro

The G1 has built-in Automatic Bracketing Control (A.B.C.) that provides a three frame, continuous (over/right on/under) exposure system. The exposure compensation dial allows for changes in exposure up to 2 EV in 1/3 step increments. The G1 also has a Custom Function Mode for customization of camera performance elements.

It's vertical travel focal plane shutter is made from lightweight materials and features precision quartz-timed shutter speeds, which range from 1/2000 second to 16 seconds in automatic AE mode (1/2000 to 1 second in manual mode). In addition, Through The Lens (TTL) flash metering is a G1 standard feature, allowing for perfect flash exposures when used with the new Contax TLA 140 or our other TLA flashes.

# CONTAX G1
### The Essence of Carl Zeiss T* Optics

CAMERA GRAND PRIX '95

**To receive a G1 full-color brochure, or to locate the nearest authorized Contax dealer, call 1-800-526-0266 ext. 4315.**

 © 1995 Contax - Division of Kyocera Electronics Inc., 100 Randolph Road, Box 6802, Somerset, NJ 08875 Kyocera Corporation Optical Equipment Group 27-8, 6-chome Jingumae, Shibuya-ku, Tokyo 150, Japan